For Dick Stowe
With warm regard
John (F. H. Gorton)
1 July 1976

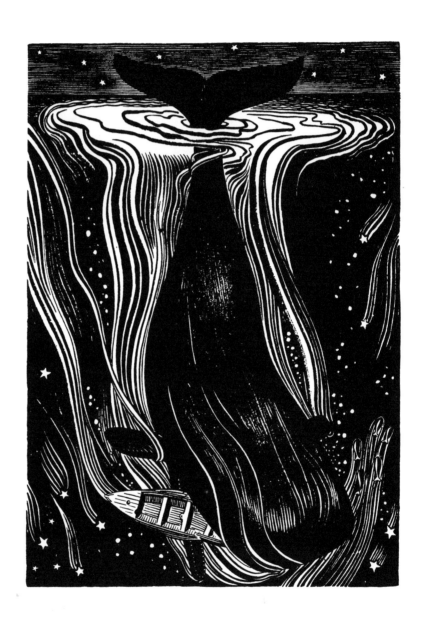

The Illustrations of Rockwell Kent

231 Examples from Books, Magazines and Advertising Art

SELECTED BY
FRIDOLF JOHNSON
WITH THE COLLABORATION OF
JOHN F. H. GORTON,
DIRECTOR, THE ROCKWELL KENT LEGACIES

WITH AN INTRODUCTION BY FRIDOLF JOHNSON

Dover Publications, Inc., New York

Published in Canada by General Publishing Company, Ltd., 30 Lesmill Road,
Don Mills, Toronto, Ontario.
Published in the United Kingdom by Constable and Company, Ltd., 10 Orange
Street, London WC 2.

*The Illustrations of Rockwell Kent: 231 Examples from Books, Magazines and
Advertising Art* is a new work, first published by Dover Publications, Inc., in
1976. A new Introduction has been written especially for this edition by Fridolf
Johnson. Illustrations drawn by Rockwell Kent for The Heritage Press edition
of *Leaves of Grass,* copyright © 1937, 1965 are reproduced by permission of
The Cardavon Press, Inc., Avon, Connecticut. Illustrations drawn in two colors
by Rockwell Kent for *Erewhon,* copyright 1934, © 1962 by The Limited Edi-
tions Club, Avon, Connecticut are reproduced with the publisher's permission.
Illustrations by Rockwell Kent for *Moby Dick* © 1930 by R. R. Donnelley &
Sons Company are reproduced with permission. Random House mark reproduced
courtesy Random House, Inc.

International Standard Book Number: 0-486-23305-7
Library of Congress Catalog Card Number: 75-28786

Manufactured in the United States of America
Dover Publications, Inc.
180 Varick Street, New York, N.Y. 10014

Frontispiece: *Moby Dick* (1930). The Battering-ram.

INTRODUCTION

During the 88 years of his life, Rockwell Kent achieved equal prominence as a painter, writer, traveler, and social polemicist. Louis Untermeyer, writing in the Special Rockwell Kent Number of *American Book Collector*, summer, 1964, proclaimed him "the most versatile man alive . . . I have known him as a painter, pamphleteer, poet (in private), politician (a poor one), propagandist, lecturer, explorer, architect (he re-designed my home in the Adirondacks), grave-digger, farmer, illustrator, Great-Dane-breeder, typographic designer, xylographer ('wood-engraver' to the uninitiated), friend, and general stimulator." To a large segment of the public, however, he is remembered as the most important American book illustrator of his time, primarily for the works he illustrated during the twenties and thirties—*Candide, Moby Dick, The Canterbury Tales* and the complete Shakespeare, as well as his own books of travel.

This period was marked by frenetic activity in the production and collecting of limited editions and fine printing. Kent's thorough understanding of typographic design, his individual, precise style of formalized realism and his techniques, so sympathetic to the printed page, made him the ideal illustrator for the kind of books appreciated by discriminating collectors. Most of his illustrated books were first published in expensive, superbly produced limited, signed editions, followed by more popularly priced trade editions having tremendous sales. Besides the then prevailing practice of issuing limited editions of fine books at higher prices, to defray the high cost of production, "special copies" with wider margins, extra plates, deluxe bindings, and other desiderata attractive to collectors were often published to bring in additional income. Rockwell Kent's books were no exception, and they present a difficult problem for bibliographers.

Kent also had the gift for creating simple, compact vignettes of strong design admirably adaptable to page decorations, signets, and bookplates; he produced a great number of bookplates, much admired and assiduously collected, and two collections containing both bookplates and marks were published in limited editions, one in 1929 and the other in 1937. In addition, he

contributed much outstanding work to numerous distinguished advertising campaigns.

Rockwell Kent was born June 21, 1882, at Tarrytown Heights, New York. That he chose to come into the world so early as four o'clock in the morning possibly suggests a proclivity and fund of energy which was to mark his entire life. He began his formal education at Horace Mann School in New York City. Later he wrote in *It's Me O Lord: The Autobiography of Rockwell Kent* (Dodd, Mead & Company, New York, 1955), "Mechanical drawing was important in our curriculum; and, again, the high degree of craftsmanship that it demanded—of accuracy of measurement, of sheer draughtmanship in terms of utmost precision—not only served, however unsuspectedly by me, to incline me toward my eventual profession, but to train my hand for service to it. But of even greater importance was the stark, material realism of which such drawing is the expression. Our concern was not with what things *looked* like but with, what in all their dimensions, they essentially were."

Of his early training there in fine art he writes caustically—and characteristically—that his generation was happily spared "all the silly, sensual indulgence in irresponsible self-expression that, from messy 'finger painting' to often messier abstractionism, characterizes much of the therapeutic school of art of today." In school he developed a good Spencerian hand, and his ability to write well and embellish what he wrote with fanciful letters and decorative borders was quickly recognized and put to use. At fifteen he began to practice as a professional, receiving small commissions suitable to his talents.

Kent studied architecture at Columbia University, briefly practiced the profession, and set himself up as an expert on architectural rendering. Finding the work unrewarding, he turned his attention more and more to painting. He had already started to study painting under William Merritt Chase in the summer of 1900. He later went to the New York School of Art, established by Douglas John Connah, a fine man and painter who has received much less credit than he deserves. There he studied under Chase, Kenneth Hayes Miller, and Robert Henri. He also spent some time in the studio of Abbott Thayer. Two oil paintings done while working one summer with Thayer at Dublin, New Hampshire were exhibited at the winter show of the National Academy and became Rockwell Kent's first sales—*Dublin Pond* to Smith College and *Monadnock* to Charles Ewing.

It was Robert Henri, a member of "The Eight," who most inspired the young Kent. In 1905, at Henri's suggestion, Kent went to Monhegan, an island off the coast of Maine, to paint on his own. In 1906 he returned to Monhegan and built a house on Horn's Hill, where he stayed for several years, supporting

himself by odd jobs which included well drilling, lobster fishing, carpentry, and lighthouse tending.

The sharp edges and strong contrasts of the rugged Maine coast, together with the mysterious aspects of the sea, were particularly stimulating to Kent's dynamic nature and set the pattern for his future work. In his landscapes, the forbidding peaks of mountains or icebergs, soaring up from a horizontal foreground of dark sea and crowned by lowering skies, were especially personal. This low perspective was to become characteristic of many of his prints and his illustrative works in which figures appear to be standing upon a stage, dominating their surroundings. Depicting them so may have been an unconscious expression of his belief in the nobility of man. The monumental stance of his figures may also have been a natural result of his years in architectural rendering.

Rockwell Kent's boundless energy and adventurous spirit led to extensive traveling in search of appropriate subject matter for his paintings. He sought subjects at Brigus, a small town on the east coast of Newfoundland, to which he emigrated with his wife and children in 1914. But the long and cheerless winters and the difficulty of going far afoot obliged him to paint indoors most of the time. In his own words, his work was "in no degree an outpouring of delight in visible nature, but, rather, a continuous wail of lamentation of man's tragic, solitary lot in the vast and soulless cosmos" (*It's Me O Lord*). This was a theme which was to recur often in his later work. The rumblings of an incipient World War were also disturbing. Despite many new friendships, Kent's sketching explorations and the deep insularity of the natives, heightened by war hysteria, provoked a ridiculous situation in which Kent was accused of gathering information for the Germans and was ordered to leave.

Rockwell Kent's career as an illustrator began inauspiciously while he was working as a draughtsman for the architectural firm of Ewing and Chappell in New York. His friend Frederick Squires had written a book and persuaded Kent to illustrate it. *Architectonics, The Tales of Tom Thumtack, Architect*, Volume One, appeared in 1914 with 85 drawings, besides initial letters, by Kent in a 174-page book in a decorative cloth binding published by The William T. Comstock Company of New York. Kent's name does not appear in the book; neither did he sign his name to subsequent effusions of that sort.

As the firm of Ewing and Chappell was not overwhelmed with commissions, George Chappell used his enforced leisure to write amusing verse. Kent made a satirical drawing for one of Chappell's poems and submitted both to Frank Crowninshield of *Vanity Fair*. Crowninshield was delighted, but insisted that the drawing be signed before buying it. Kent, not wishing to be identified

with such frivolous work, made a tactical retreat by writing "Hogarth, Jr." at the bottom. The team of Chappell and Hogarth, Jr. sold many more of their efforts to *Vanity Fair*, in the beginning netting about ten or fifteen dollars apiece each time. These works were finally gathered into a book entitled *A Basket of Poses*, published by Albert & Charles Boni in 1924. Crowninshield was a steady patron of Kent's for years; Kent also made amusing drawings for *Puck*, the old *Life, Harper's Weekly*, and other magazines, signing them "Hogarth, Jr." or simply "H. Jr."

His commercial work and the sale of a few paintings, as well as a commission for a mural, made it possible for Kent to realize his dream of visiting Alaska. In 1918 he and his eight-year-old son, Rockwell III, holed up in a small cabin on Fox Island, off Resurrection Bay, uncomfortably close to the Arctic Circle. It was a Spartan experience, but as Kent wrote in *It's Me O Lord*, "The steel-sharp, bitter nights, the vast and heartless depths of space that they revealed, enhanced the warmth and comfort of our cabin. There we would sit, we two, the only living beings, so it seemed, in all the universe." Kent painted by day and drew by lamp-light at night. Here the sterile distractions of civilization were replaced by the simple chores of cutting firewood, cooking and baking bread, and long thoughts on fundamentals. Much of his work done here, especially his figure compositions, some of which appear to have been conceived while in a mystic mood, has been compared to that of William Blake, whom he admired. However, the similarity falls far short of imitation. Kent's vision was his own, expressed in much more emphatic contrasts of strong darks and lights and with an uncompromising directness of solid, geometrical forms.

When father and son returned to New York the next year, the family funds were nearly depleted, and the Kents barely squeaked through the acquisition of a house on about one hundred acres on the southern spur of Mt. Equinox in Vermont. It was the fifth house to be refurbished by Kent in less than ten years. By the time the house was ready for occupancy, money had run out again. Kent conceived the idea of incorporating himself on the strength of his future and a great number of unfinished canvases. A few friends bought stock at $100 a share, and Kent drew enough salary from the corporation to cover his expenses while finishing his Alaskan paintings. His exhibition at Knoedler Galleries in March, 1919 was a great success and Kent bought back all the stock in himself and paid a corporate dividend of twenty percent.

During the long nights in Alaska, Kent had written a journal in the form of letters to his family and friends at home, and these became the largely unedited text of his first book at the suggestion of George Putnam, one of his shareholders. *Wilderness: A Journal of Quiet Adventure*, with drawings by

the author, was published by G. P. Putnam's Sons on March 19, 1920, causing quite a stir. It was reprinted twice, and re-issued in the smaller format of the Modern Library in 1930.

Not so quiet as the Alaskan interlude was his second trip in search of subjects, this time, in 1922, to the wilderness of Tierra del Fuego at the tip of South America, where he lived for a year. His experiences there were related in *Voyaging Southward from the Strait of Magellan*, with 100 illustrations by the author, which was published by Putnam's in October, 1924 and sold so

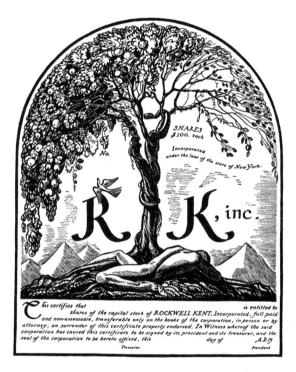

In 1919, having returned from Alaska and refurbished a house in Vermont, Kent ran out of money. The artist incorporated himself and sold stock to friends, with certificates which he designed.

well that a second edition was issued the following month. There was also a deluxe edition of 110 numbered and signed copies with an additional signed woodcut in two colors.

That year, Kent exhibited his Tierra del Fuego paintings at Wildenstein Galleries in New York. The tempo of his life quickened, and the next few years were very busy ones. Kent visited France and Ireland, had another exhibition at Wildenstein, made his first trip to Greenland and went to Denmark in 1928; in between, he established a permanent home at Asgaard Farm in the Adirondacks and managed to complete a mass of drawings that put him in the first rank of American illustrators.

Kent had taken up the practice of wood engraving about this time. His friend, Carl Zigrosser, the eminent print historian, had given Kent some blocks and tools to try out in Alaska, but it was not until he was settled in Vermont that he took up the craft in earnest. The medium was particularly adaptable to Kent's preferences for definite shapes, clear, sharp lines, and strong contrasts of definite tones.

Kent's wood engravings were widely exhibited and reproduced, and were bought by museums and collectors. In these he made telling use of solid areas with a minimum of shading. Most of them were of nude male figures, perhaps standing in the riggings of a ship and dramatically looming out of a black sky sprinkled with stars. They are considered prime examples of his finest work in black-and-white. The American Car and Foundry Company used some in a series of distinguished advertisements, and eight of them were included as supplements to the illustrations for the deluxe edition of *N by E.* Kent designed a great number of fine prints, and over 200 of these, plus 106 sketches, tracings and drawings related to them have been reproduced in a monograph and documented catalogue, *The Prints of Rockwell Kent,* by Dan Burne Jones recently published by the University of Chicago Press.

Wood engraving became second to painting in the arts he practiced, and many of his *Wilderness* and *Voyaging* drawings, done with ink and a pointed brush or pen, already had a marked similarity to wood engravings with their firm outlines, solid black areas, and clear tones made of parallel lines. For smaller drawings such as designs for bookplates, marks, and vignettes for page decorations, Kent began to draw with a pen in a precisely shaded style, somewhat reminiscent of nineteenth-century illustrative engravings, but with a definite contemporary flavor. It was this clear-cut style that was to become popularly associated with his name.

Kent's informed interest in all the details of book design and the affinity of his line technique to typography made the transition from painter to illustrator a natural one. For many years Rockwell Kent earned a living principally as a graphic designer. He was deluged with commissions to illustrate books, to design book jackets, marks, and bookplates, and to make drawings for advertisements. The Rockwell Kent style of drawing was widely—but ineptly—copied by imitators.

His pen-line vignettes for *Dreams and Derisions,* privately printed in a limited edition in 1927, are typical of his style as are the drawings he made for his following book. Bennett Cerf and Donald Klopfer, owners of the highly successful Modern Library series, made publishing history when they decided to issue other types of books "at random," using the name Random House as

their imprint. They chose Rockwell Kent to illustrate the first title, Voltaire's *Candide.* During a discussion in Cerf's office, Kent casually drew for them the trademark they have adopted for use in various forms ever since.

In 1928 *Candide* appeared in a limited edition, illustrated by Rockwell Kent and executed by Pynson Printers under the direction of Elmer Adler. The text was set by hand in a new type designed by Lucian Bernhard; an interesting feature was the introduction of tiny typecast human figures designed by Kent which were used to mark new paragraphs, thereby eliminating the need for distracting indentations and short lines at the ends of paragraphs. The book's flawless format, with a superbly chaste gold-embossed binding and complete harmony between type, paper and illustrations—almost silvery in tone—brought instant recognition as "one of the finest specimens of printing done in recent years." It was chosen by the American Institute of Graphic Arts for its "Fifty Best Books of the Year" for 1929, and in 1934 as one of the best fifty from the 500 exhibited during the past ten "Fifty Books" shows.

The limited edition was quickly exhausted, going into fine libraries and private collections. That same year (1928) the book was reset in Garamond type and published in red cloth, as well as in a special edition in blue cloth issued by the Literary Guild. Though naturally not as impressive as the impeccably produced limited edition, through their distribution and exposure to many who perhaps had never seen a fine book before, Kent's work came to the attention of a much wider public than is ordinarily achieved by an American illustrator, barring such favorites as Norman Rockwell. (In fact, the similarity of their names often caused the two to be confused in the public mind. Both Rockwell Kent and Norman Rockwell were regularly amused and often annoyed by being mistaken for each other. Compounding the confusion was the name of Norman Kent, another well-known artist and print-maker, and for years Editor of *American Artist* magazine.)

About the time Kent had finished the drawings for *Candide,* he was approached by William Kittredge, design director of the Lakeside Press of Chicago, to design and illustrate one of a series of four books by American authors the Press wished to publish in limited editions as examples of their craftsmanship in bookmaking. Kent proposed that he do an edition of Herman Melville's *Moby Dick.* The theme of Captain Ahab's passionate pursuit of the great white whale, with its mystical undertones, excited Kent, and between workdays he spent long hours in research, steeping himself in whaling lore. He delivered the first drawing to Lakeside on June 20, 1927. Kent and Kittredge worked together on every detail of the book's design and typography with such enthusiasm that what was to be a single volume turned out to be

a three-volume set with 280 illustrations. At Kent's suggestion, the set was enclosed in an aluminum slipcase, and the limited edition of 1000 sets appeared in 1930 with much fanfare. The Press also issued a one-volume, 860-page trade edition with the same illustrations reduced and the text reset in smaller type.

The year 1930 also saw the publication of two more important books illustrated by Rockwell Kent: *The Canterbury Tales of Geoffrey Chaucer*, and *N by E*, in which the artist describes his first trip to Greenland the year before. *N by E* was a best-seller and a Literary Guild choice, going into several reprints. Kent was to visit Greenland twice more, using his experiences there as material for other popular biographical books.

Kent was enormously productive during this period, being able to work with prodigious energy and facility wherever he happened to be. Besides his fully illustrated books, he made jackets, frontispieces, or minor illustrations for at least eighteen additional books, and, of course, many bookplates and advertising drawings. Kent's drawings were seen everywhere. There were those who charged him with working too much with an established formula to supply the demand. To a certain extent, the objection seems justified in the 24 full-page drawings he made for the *Canterbury Tales*, which are barely illustrative, being uniformly full-length portraits of the principal characters with backgrounds consisting mostly of his characteristic horizontal shading lines. However, no one could fault him for the great variety of compositions and details in *Moby Dick* and *N by E*.

In the Chaucer illustrations, Kent varied his customary style somewhat by separating the line-work into black and a second color, using some solid areas and overlapping of both colors to create a chiaroscuro effect. His rather formal and spare line drawings for Shakespeare's *Venus and Adonis* (1931) are also printed in two colors. The 42 charming decorations he made for *City Child*, a slender book of poems by Selma Robinson, appeared in 1931.

A Birthday Book, as published the same year in a limited edition, was quite different. The silk binding, lithographed in blue and with red stamping, and the 20 illustrations in greenish black, set in frames of hand-written text and decorative designs in gray and olive green, are delightful. The entire production, though elaborate, escapes the cloying prettiness one might expect from such a format and such a subject.

For *Beowulf*, the only important Kent item published in 1932, he switched to lithography, a medium he had practiced for several years. Designed by Kent, with a large page-size of more than ten by thirteen inches and eight smoothly executed original lithographs, it is an impressive book. The text, printed in

black and red with blue and red decorative initials drawn by the artist, was set by hand in American Uncial, an allusive type newly designed by Victor Hammer and an inspired choice for conveying the spirit of the ancient English epic. Only 950 copies were printed by Pynson, and Kent signed them with his thumbprint.

In 1934 the Limited Editions Club issued an edition of Butler's *Erewhon* to its 1500 members. Kent created ten full-page illustrations printed in various two-color combinations; the 29 chapter headings, in line, however, were not very successful. Kent returned to his earlier, sketchy style in the full-page ink-and-crayon illustrations for *Salamina* (1935), a lovely book about the artist's intimate life with the Eskimos. The illustrations were printed in dark brown ink.

The more flexible, and perhaps more rapidly executed technique of ink and crayon combined seems to have appealed to Kent, and he used it to splendid effect in the 40 powerful, full-bodied illustrations for the *Complete Works of William Shakespeare* (1936) and a few other books. He must have enjoyed illustrating Esther Shephard's book on Paul Bunyan, the American giant folk hero. It is a jolly book, with 22 lively full-page drawings and some brightly conceived initial letters with figures worked into them. Some of the illustrations are full of incident and background detail, revealing a new trend in Kent's illustrative composition.

His double-page drawings for *Goethe's Faust*, published in 1941, follow this trend; they are also shadowy and densely textured in their line-work, in keeping with the occult implications of the subject. His last important book commission was the two-volume *Decameron of Giovanni Boccaccio*, which appeared in 1949. The full-page illustrations for this set are also on the dark side, with fuller backgrounds and the addition of washes in two colors.

Kent's working methods were adapted to the occasion, to the subject, and to deadlines, as every professional graphic artist will realize. He usually did his illustrations from preliminary sketches and tissue tracings, carefully adjusting the texture of his rendering to the percentage of photographic reduction. His friend, Dan Burne Jones, writes: "RK worked about twice size in many instances, and sometimes larger, with brush in combination with pen-and-ink." His drawings are best judged in the exact size of reproduction he intended them to be; they have suffered somewhat from excessive reduction in some editions.

Rockwell Kent's high place in the history of American book illustration rests more firmly upon work done during the brief period when he had virtually complete control over every detail of format, typography, printing,

and binding. A baker's dozen or so of these books will long remain as outstanding examples of the finest traditions of printing and bookmaking. Unhappily, long before his career as an illustrator came to an end, the demand for perfection in these matters had begun to wane; after the stock market crash of 1929 publishers and printers felt the pinch of adverse economic conditions and buyers of limited, illustrated editions became fewer and fewer.

Rockwell Kent was of average height, lean and sinewy, his strong, rather stern features dominated by the intensity of his eyes under bushy brows. He was prematurely bald, but wore a thin moustache which whitened with the years. As could be expected, he had a free and unconventional approach to life and to other people, but behind this pleasant facade was an individual with strong opinions and a facility for expressing them.

In the late thirties he had joined many organizations and committees with aims not appreciated by established authority, and in time he came under the baleful scrutiny of Senator Joseph R. McCarthy, who accused him of being a Communist. Kent always denied that he was, but, intransigent and crusty to the last, he continued to fight against what he considered social inequities to the end of his life. In the press, his acrimonious exchanges with his critics overshadowed his reputation as an artist, and doors were closed against him one by one.

His book, *This is My Own* (1940) gives a lively account of his controversial activities and his experiences in rural communities. *It's Me O Lord*, published in 1955, is an unabashed and thoroughly readable self-portrait and review of his entire life, copiously illustrated with drawings and reproductions of his paintings. His last important travel book, *Rockwell Kent's Greenland Journal*, appeared in 1963. After having suffered a stroke, his eventful life came to an end March 13, 1971. Ironically, in most obituaries, more space was given to his political battles than to his stature as a painter and illustrator.

FRIDOLF JOHNSON

Woodstock, N.Y.

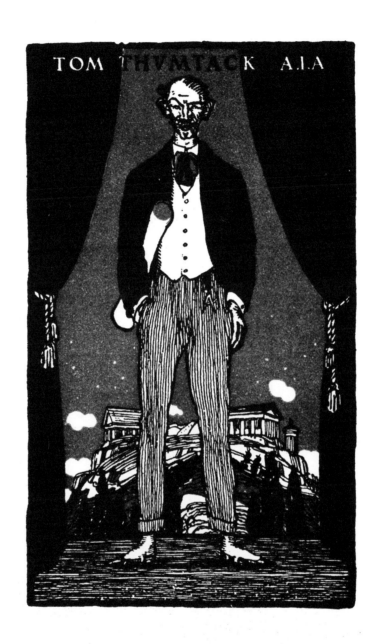

Architectonics (1914). Frontispiece.

Architectonics (1914). Two chapter headings.

Magazine illustration (1915). For *Vanity Fair*.

Two magazine illustrations (1915). TOP: Plutarch Lights of History, for *Harper's Weekly*. BOTTOM: The Talker, for the old *Life*.

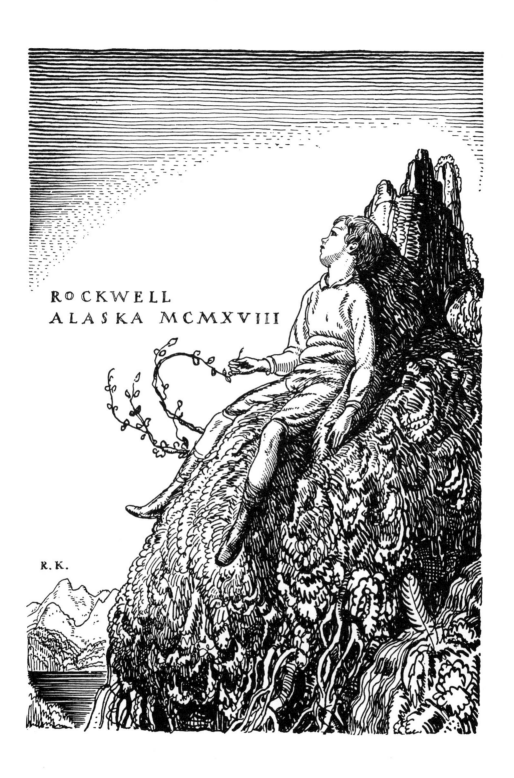

ROCKWELL
ALASKA MCMXVIII

R.K.

Wilderness (1920). Frontispiece.

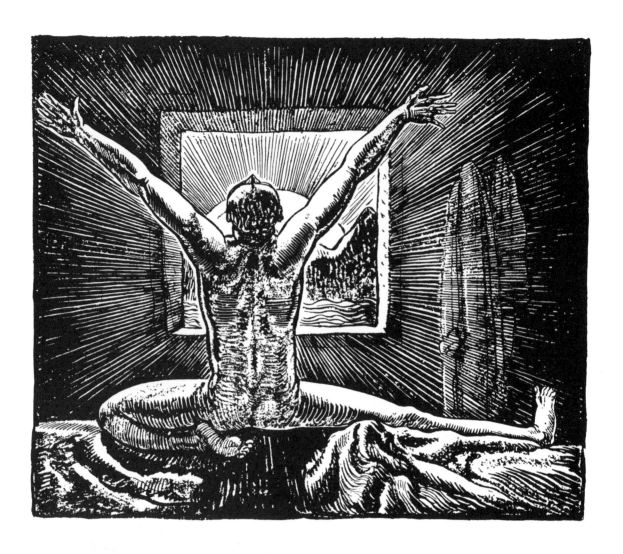

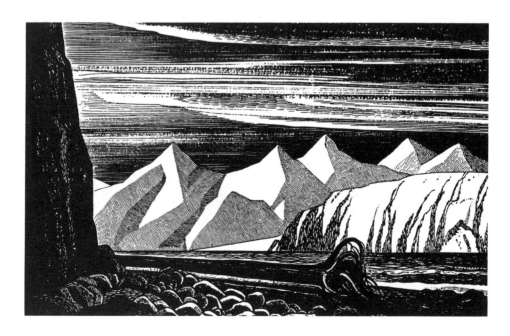

6 *Wilderness* (1920). TOP: "Get Up!" BOTTOM: Title-page drawing.

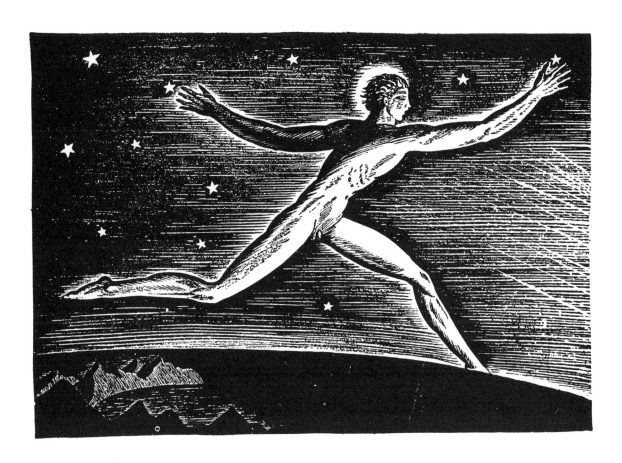

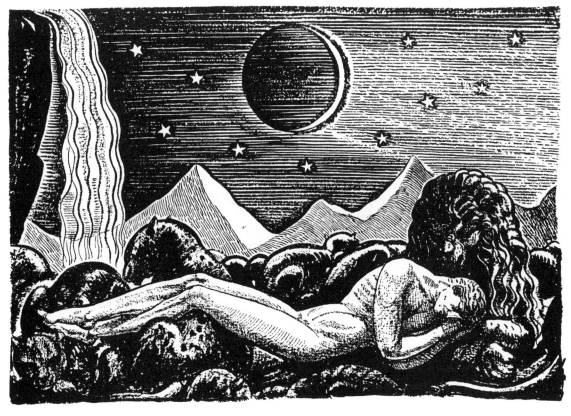

Wilderness (1920) TOP: The Star-Lighter. BOTTOM: Zarathustra and His Playmates.

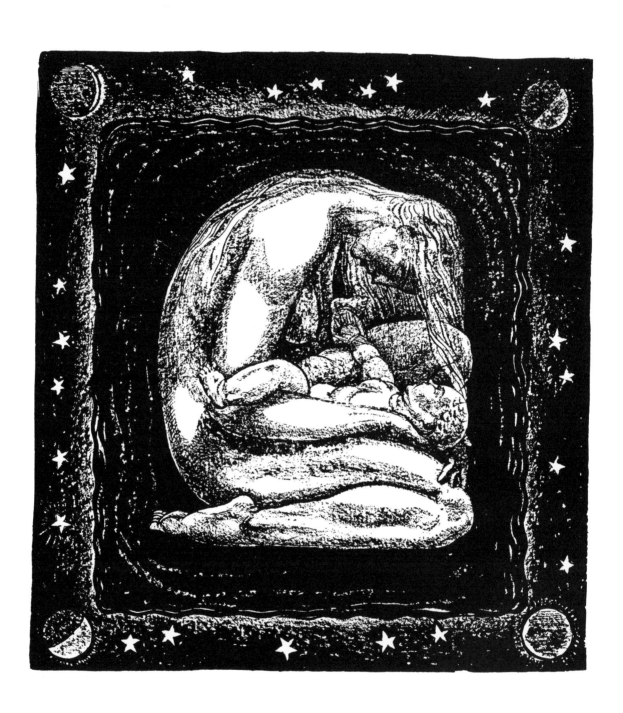

Wilderness (1920). Woman.

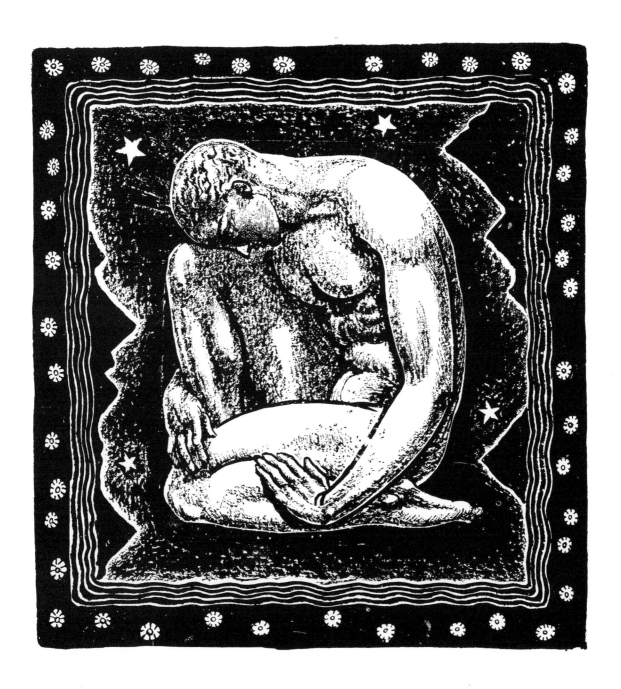

Wilderness (1920). Man.

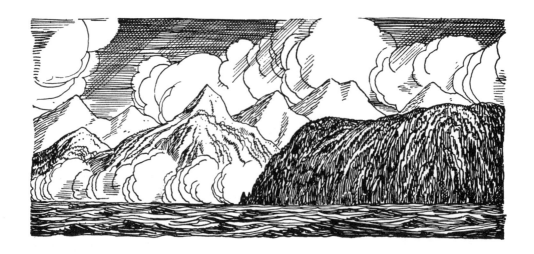

Wilderness (1920). TOP TO BOTTOM: Journal headpiece—Friday, October Eighteenth; Cabin Interior—The Air-tight Stove; Cabin Interior—Studio End.

Wilderness (1920). TOP: Fox Island, Resurrection Bay, Kenai Peninsula, Alaska.
BOTTOM: Fox Island Cabin.

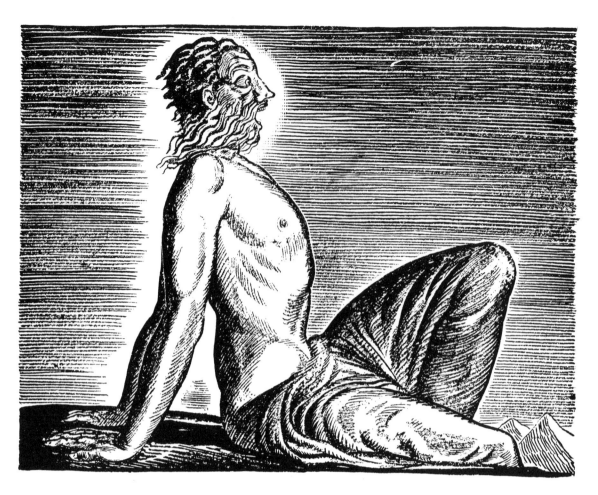

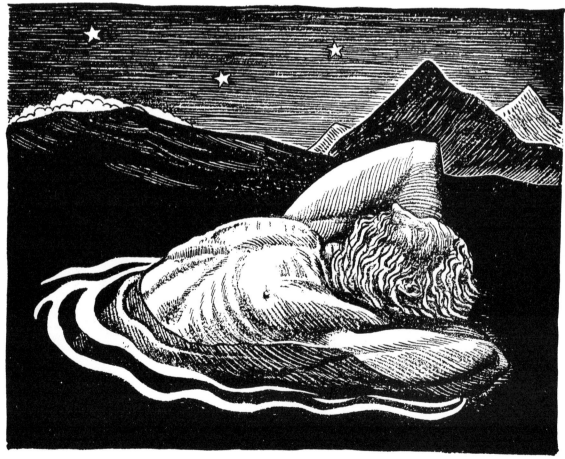

Wilderness (1920). From "The Mad Hermit," a series of seven drawings made on Fox Island. TOP: Ecstasy. BOTTOM: Pelagic Reverie.

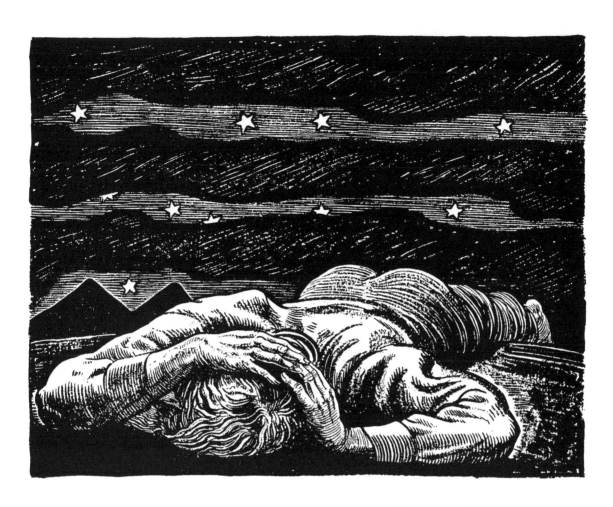

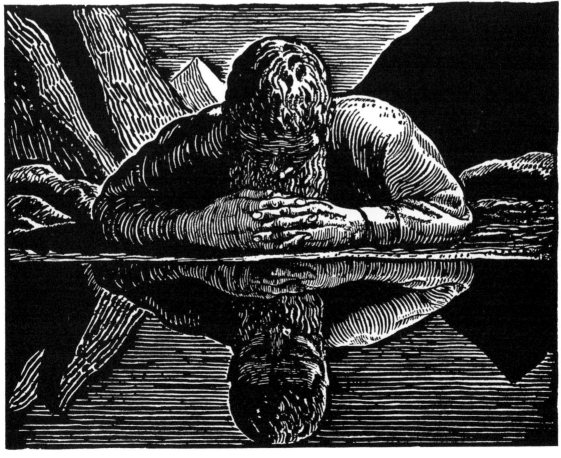

Wilderness (1920). From "The Mad Hermit," a series of seven drawings made on Fox Island. TOP: Prison Bars. BOTTOM: Immanence.

13

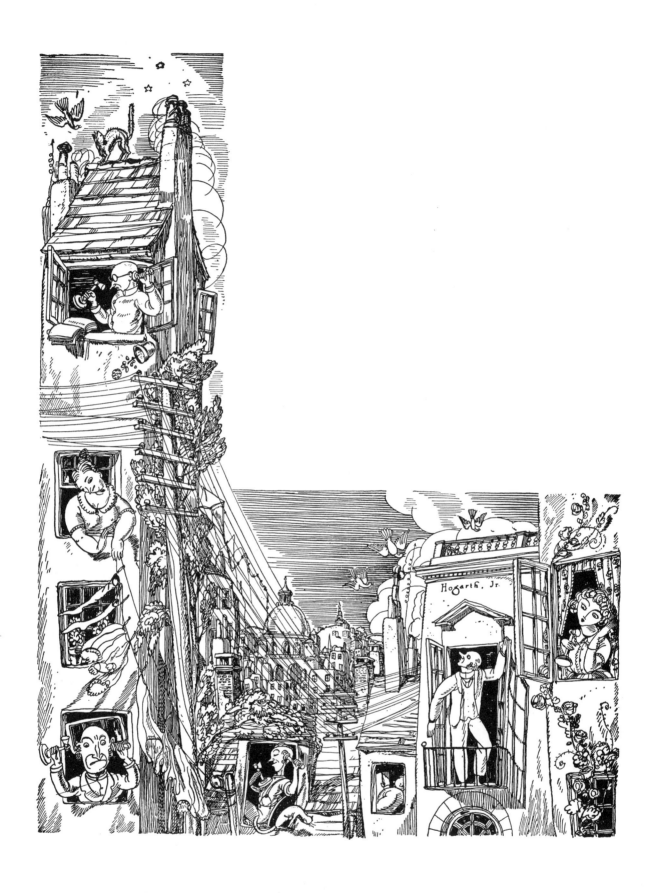

A Basket of Poses (1924). "The Party Wire."

A Basket of Poses (1924). LEFT: "Soul Mates, Affinities." RIGHT: "Any Way But Normal." 15

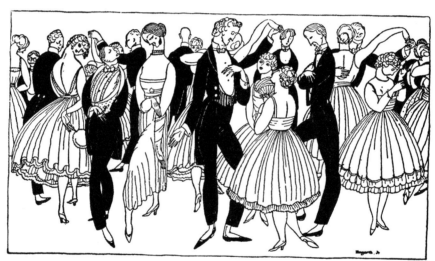

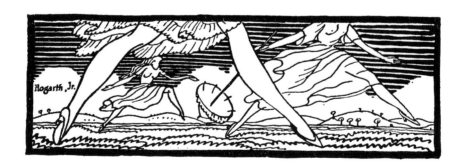

A Basket of Poses (1924). TOP TO BOTTOM: "Th' Avenue"; "The Movie Ball"; "Metaphysics."

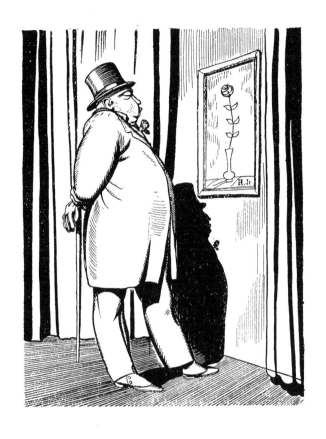

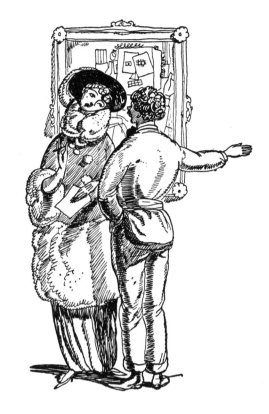

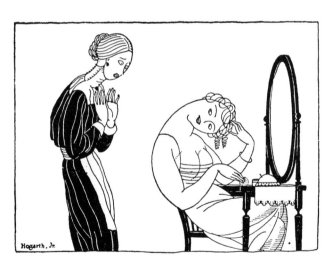

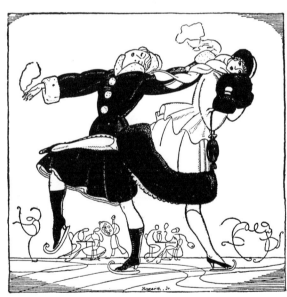

A Basket of Poses (1924). TOP LEFT: "The Collector." TOP RIGHT: "Wilfred." BOTTOM
LEFT: "Hygiene." BOTTOM RIGHT: "Figure Skating."

18 *Voyaging* (1924). Frontispiece.

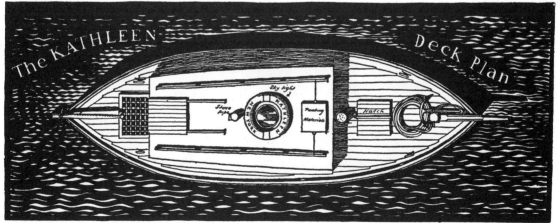

Voyaging (1924). TOP: *Kathleen* As She Was. BOTTOM: The *Kathleen*, Deck Plan.

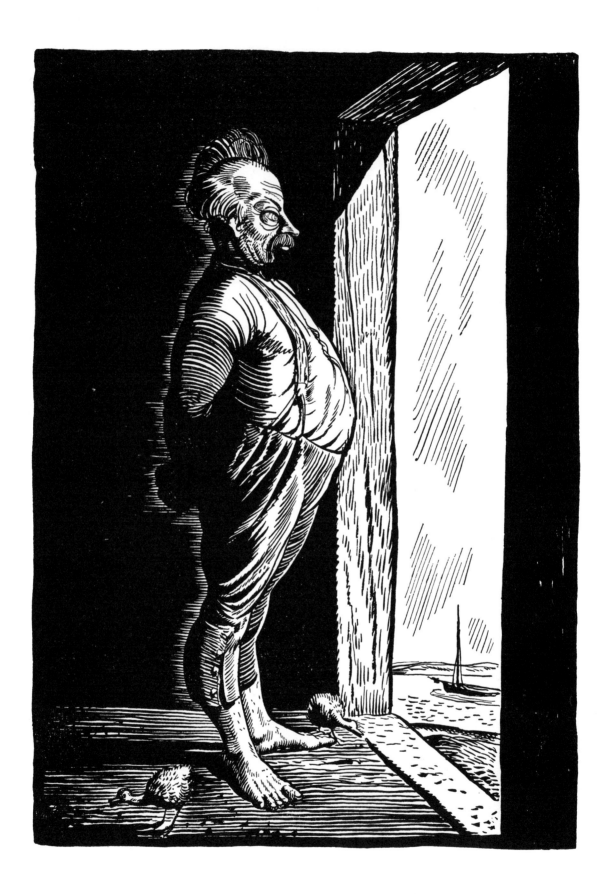

Voyaging (1924). The Inspector.

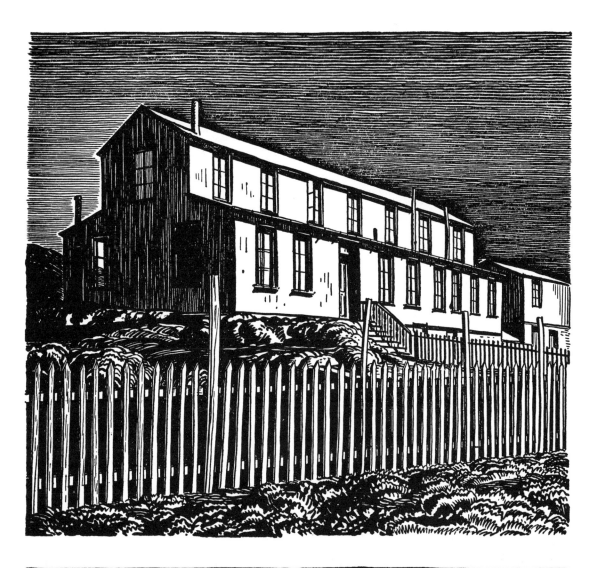

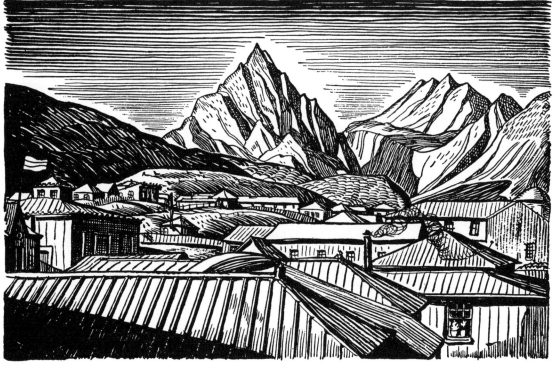

Voyaging (1924). TOP: The House at Harberton. BOTTOM: Mount Olivia.

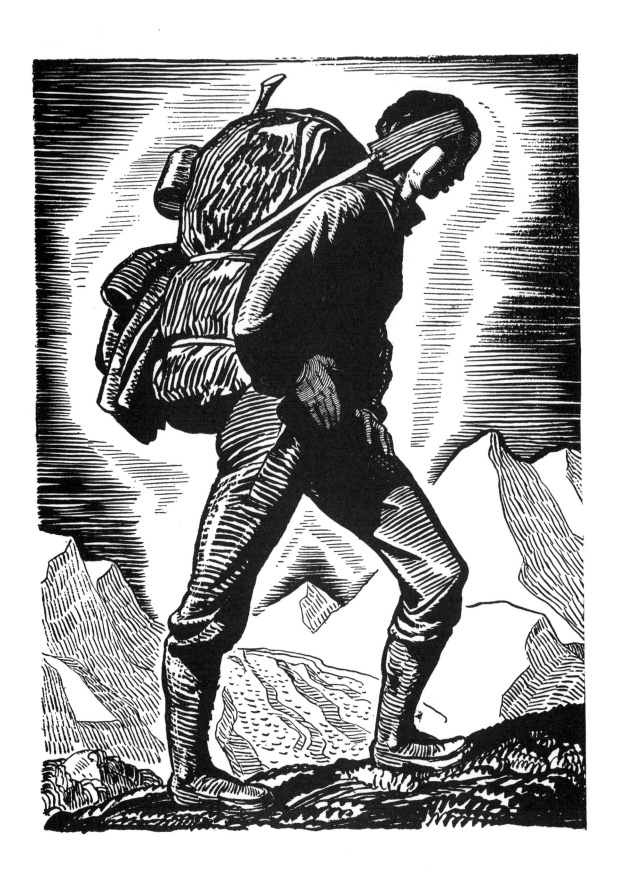

Voyaging (1924). Land Legs.

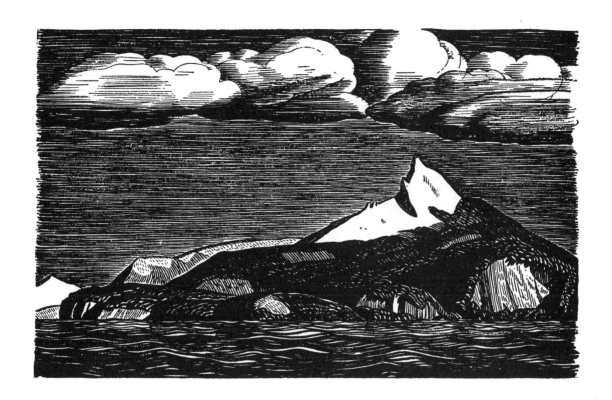

O du fröhliche,-
o du selige —

gnaden brin—
gende Weih-
nachtszeit

Voyaging (1924). TOP: Mount Seymour. BOTTOM: Christmas Eve.

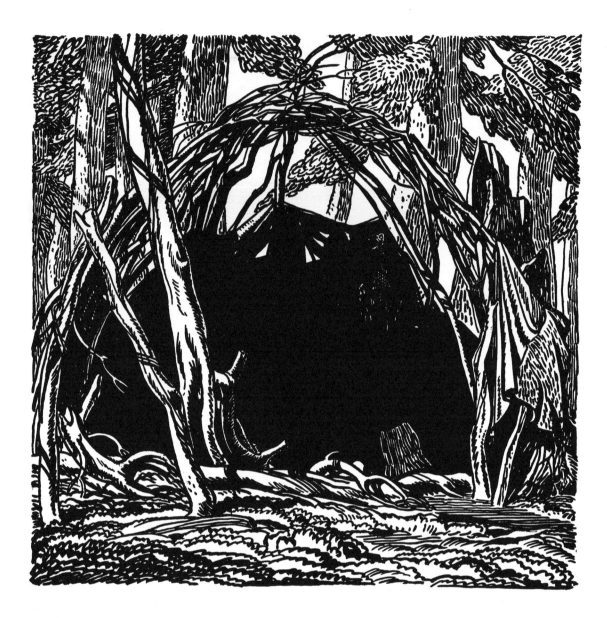

Voyaging (1924). TOP: Ona Wigwam. BOTTOM LEFT: Dedication mark, "To Kathleen."
24 BOTTOM RIGHT: Endpiece.

Dreams and Derisions (1927). Headpiece for poems, printed in brown ink. TOP LEFT: "E.W.P." TOP RIGHT: "Epitaph L.B." MIDDLE LEFT: "A Hymn to Hobcaw." MIDDLE RIGHT: "Revelation." BOTTOM LEFT: "Revelation." BOTTOM LEFT: "Valentine." BOTTOM RIGHT: " 'Class.' "

Dreams and Derisions (1927). Headpieces for poems, printed in brown ink. TOP LEFT: "The Valentine." TOP RIGHT: "Contrarious." MIDDLE LEFT: "The Amorist." MIDDLE RIGHT: "Rondeau of Resignation." BOTTOM LEFT: "Rhyme to a Hostess." BOTTOM RIGHT: "A Valentine."

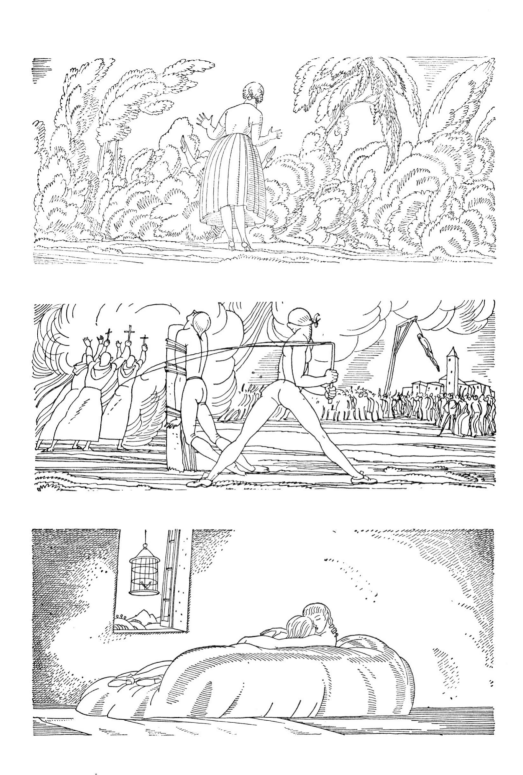

Candide (1928). TOP TO BOTTOM: "She observed Doctor Pangloss in the bushes, giving a lesson in experimental physics to her mother's waiting maid"; "The one to receive a hundred lashes, the other to be hanged"; "And after supper they returned to the handsome sofa."

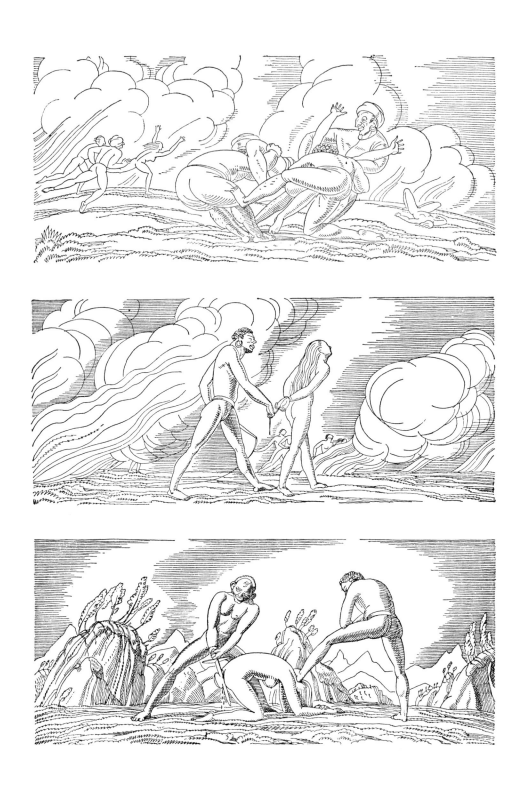

Candide (1928). TOP TO BOTTOM: "A Moor grasped my mother by the right arm, my captain's lieutenant held her by the left arm"; "A merchant bought me and carried me to Tunis"; "This horrible operation was performed on us."

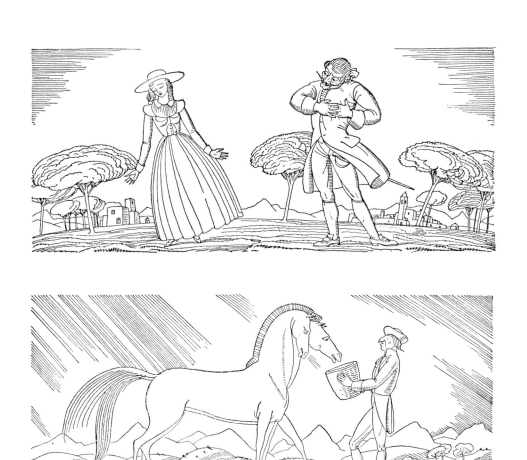

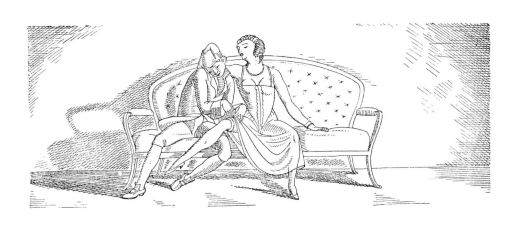

Candide (1928). TOP TO BOTTOM: "He declared his passion"; "Cacambo fed them with oats near the arbour"; " 'But I want you to put it on again,' said the lady."

Candide (1928). Colophon page. At bottom, the first appearance of the Random House trademark.

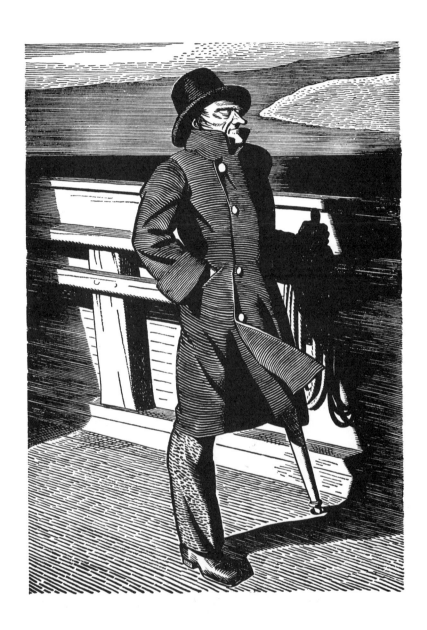

Moby Dick (1930). Captain Ahab.

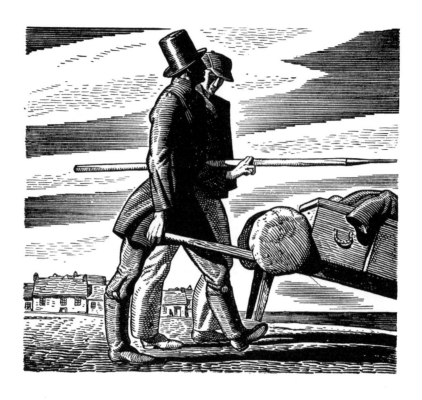

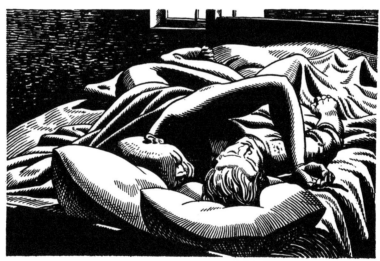

Moby Dick (1930). TOP: "We borrowed a wheelbarrow." BOTTOM: "Upon waking next morning at daylight, I found Quequeg's arm thrown over me."

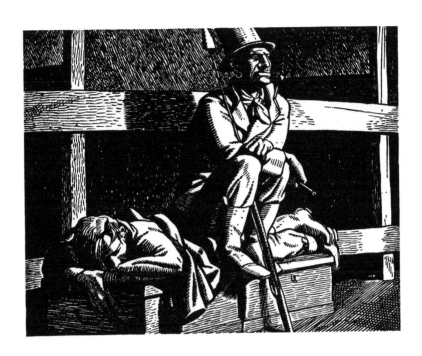

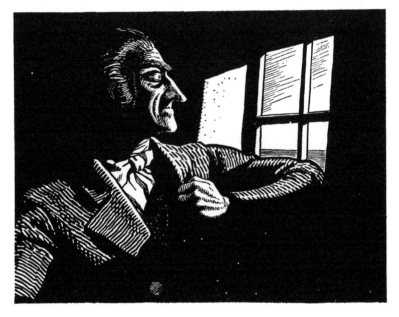

Moby Dick (1930). TOP: "And then, without more ado, sat quietly down there." BOT-
TOM: "Ahab sitting alone, and staring out."

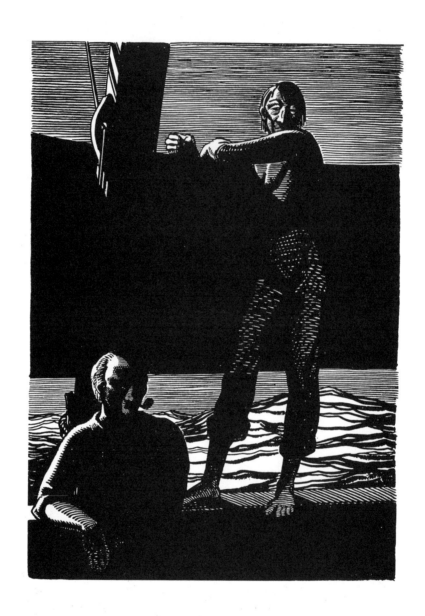

Moby Dick (1930). Tubb and Flask on Deck.

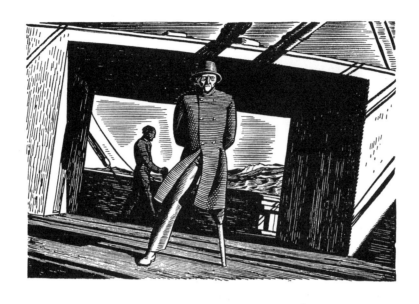

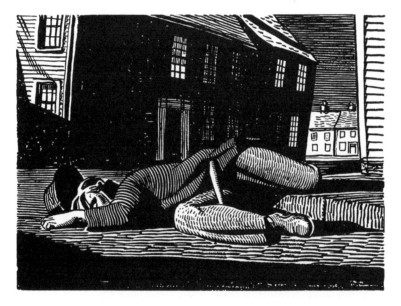

Moby Dick (1930). TOP: Ahab on the Quarter-deck. BOTTOM: "He had been found one night lying prone upon the ground, and insensible."

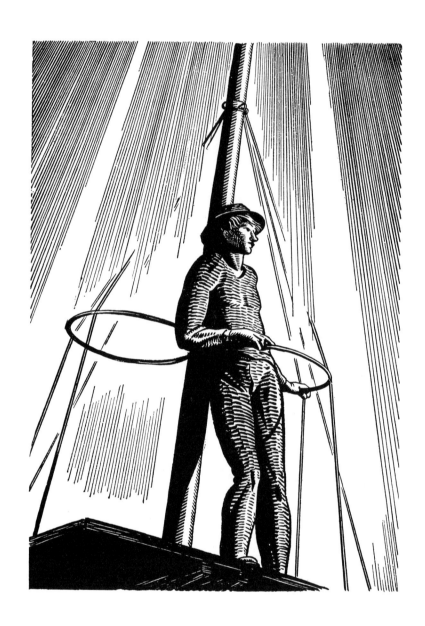

36 *Moby Dick* (1930). The Look-out.

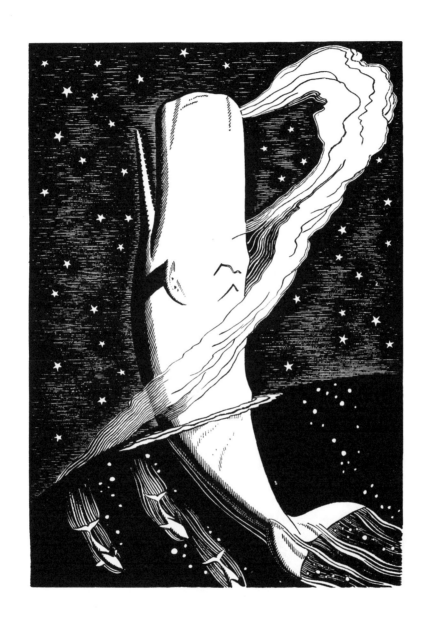

Moby Dick (1930). The White Whale.

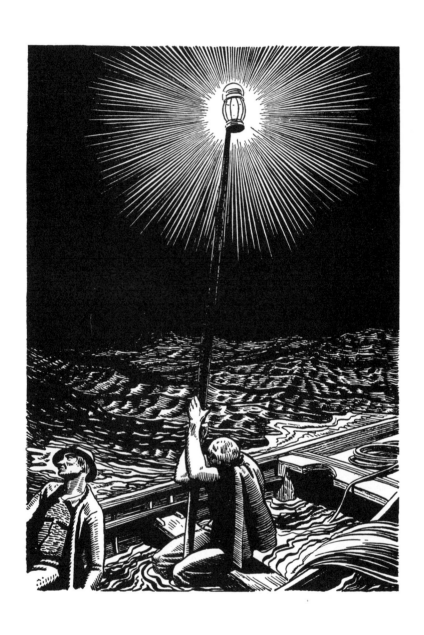

Moby Dick (1930). "'There, then, he sat, holding up that imbecile candle in the heart of that almighty forlornness."

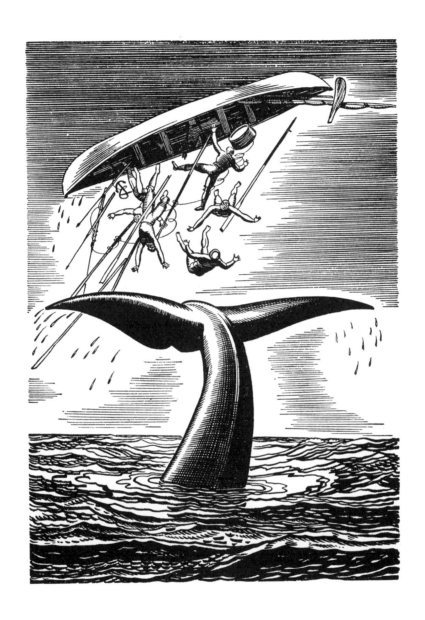

Moby Dick (1930). "Much more may the great whale outlast all hunting."

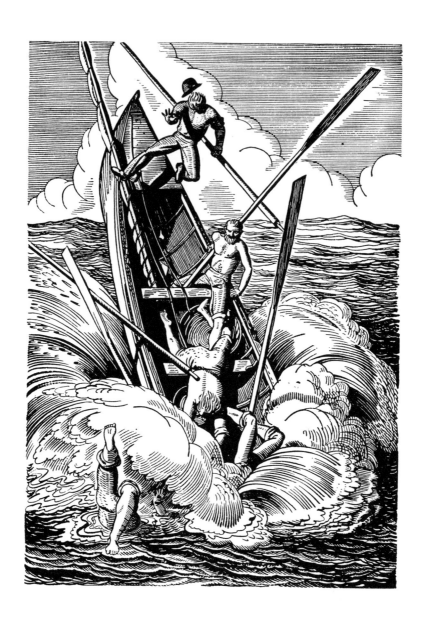

Moby Dick (1930). "As it was, three of the oarsmen . . . were flung out."

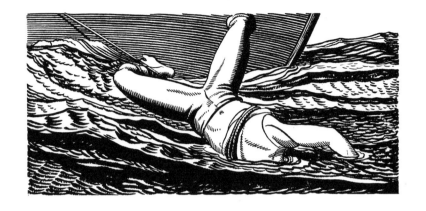

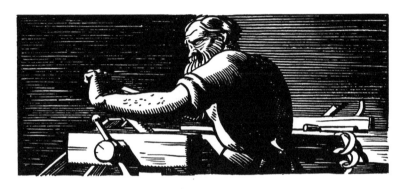

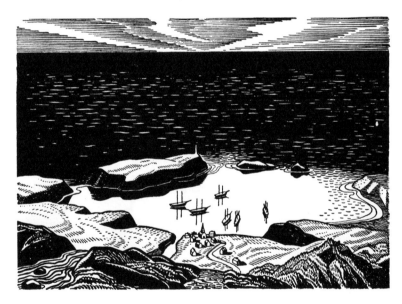

Moby Dick (1930). TOP TO BOTTOM: The Line; The Carpenter; New Bedford Harbor.

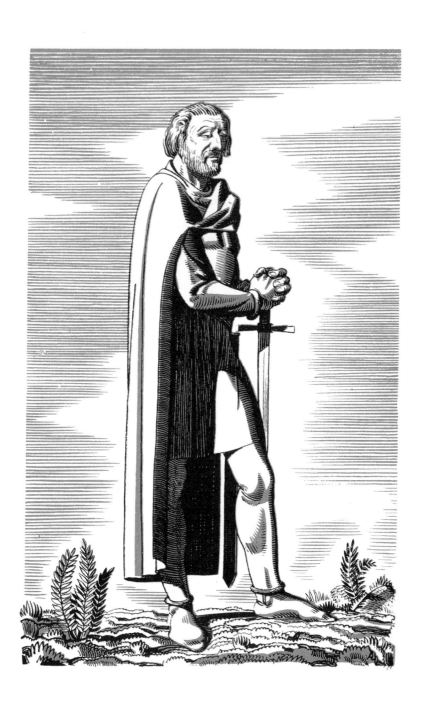

The Canterbury Tales of Geoffrey Chaucer (1930). The Knight. Illustration in black and bistre.

The Canterbury Tales of Geoffrey Chaucer (1930). The Friar. Illustration in black and bistre.

The Canterbury Tales of Geoffrey Chaucer (1930). The Clerk. Illustration in black and bistre.

The Canterbury Tales of Geoffrey Chaucer (1930). The Manciple. Illustration in black and bistre.

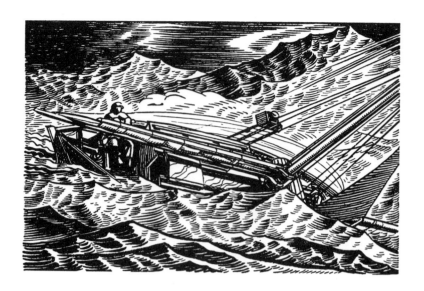

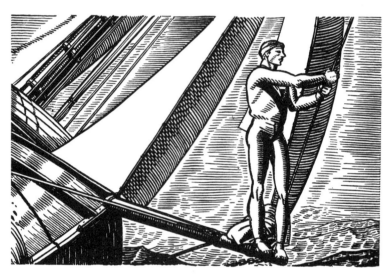

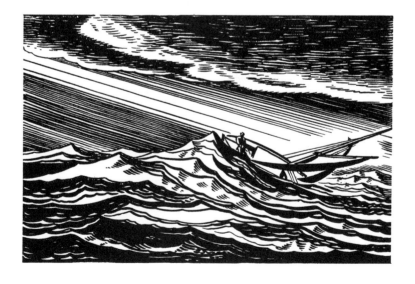

N by E (1930). TOP TO BOTTOM: "If anything, the wind and sea increased that night";
"It was the end of my morning watch"; "All day the wind continued."

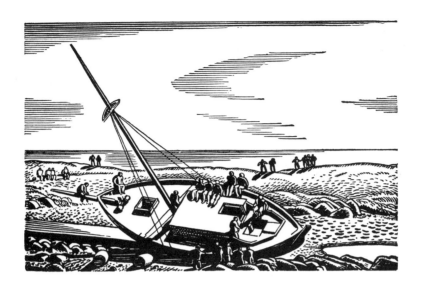

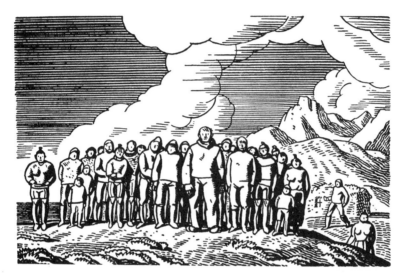

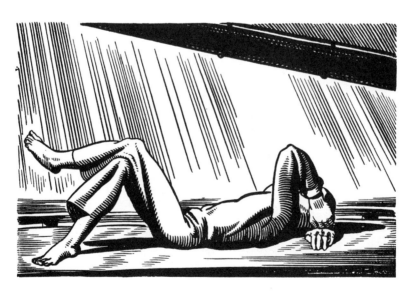

N by E (1930). TOP TO BOTTOM: "A battered derelict, beached at Godthaab"; People of Narsak; "We could lie upon a dripping deck and stare into a blue and cloudless upper sky."

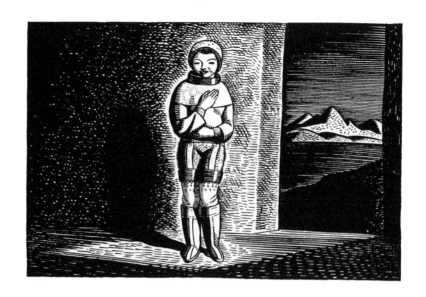

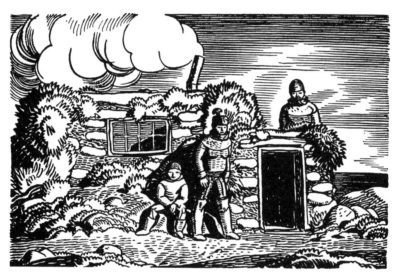

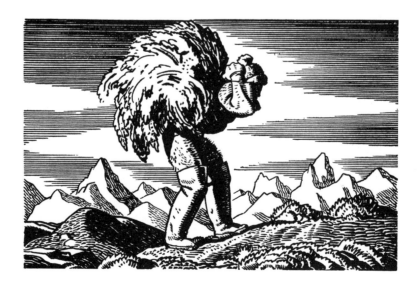

N by E (1930). TOP TO BOTTOM: Young Greenland Girl in Her Finery; House at Narsak; Trader from Baffin Land.

N by E (1930). TOP TO BOTTOM: "Skipper and Mate wedged in their tilted berths"; "We're running in a heavy sea"; "The kinds of goings-on that were disclosed to me."

A Birthday Book (1931). Complete page. Center panel printed in greenish black, surrounded by decorative frame and hand lettering in gray.

"Alas!" murmured the good fairy, "So it must be!

And that you may fulfil that destiny, BE young all the years of your life ~ even though you live to be a hundred!"

A Birthday Book (1931). Complete page. Center panel printed in greenish black, surrounded by decorative frame and hand lettering in gray.

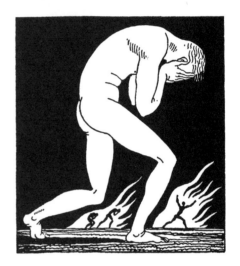

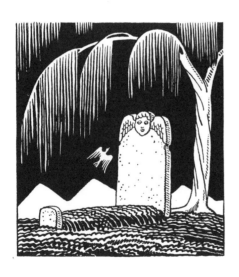

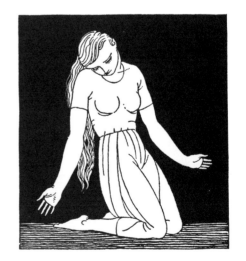

A Birthday Book (1931). Center panels from various pages.

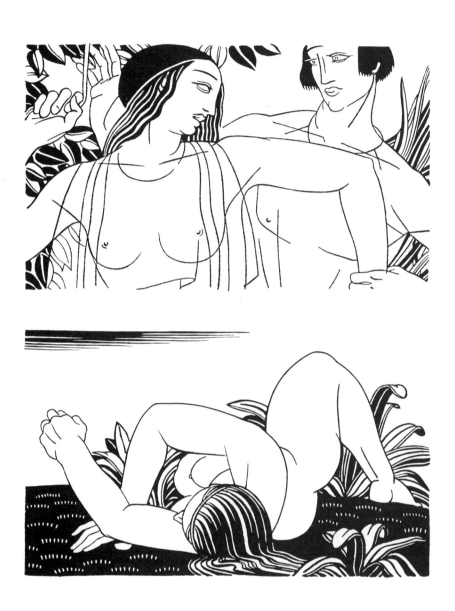

Venus and Adonis (1931). TOP: "Backward she push'd him, as she would be thrust, /
And govern'd him in strength, though not in lust." BOTTOM: "Even so confounded in
the dark she lay, / Having lost the fair discovery of her way."

53

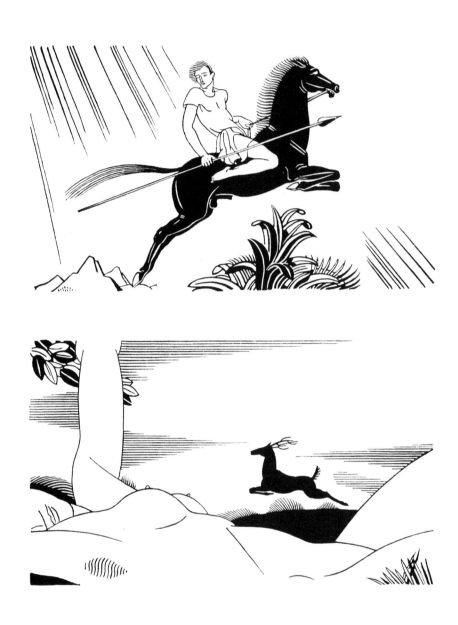

Venus and Adonis (1931). TOP: "Rose-cheek'd Adonis hied him to the chase; / Hunting he lov'd, but love he laugh'd to scorn." BOTTOM: " 'Then be my deer, since I am such a park.' "

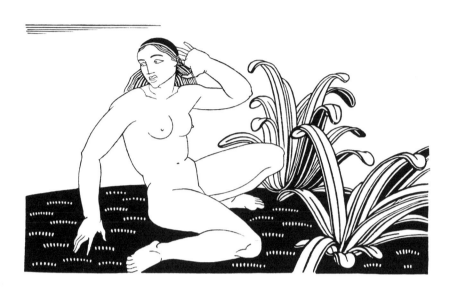

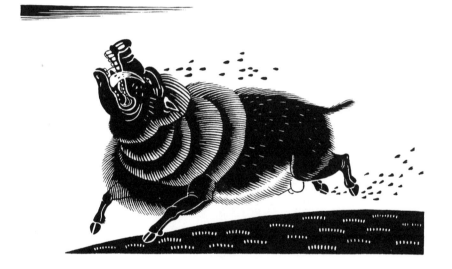

Venus and Adonis (1931). TOP: "This dismal cry rings sadly in her ear, / Through which it enters to surprise her heart." BOTTOM: " 'Whenas I met the boar, that bloody beast, / Which knows no pity, but is still severe.' "

BEOWULF

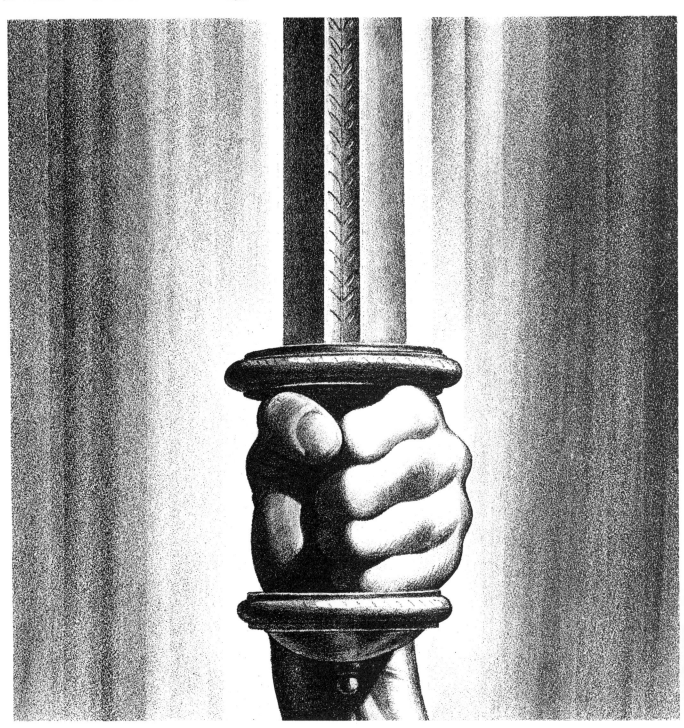

NEW YORK · RANDOM HOUSE · 1932

Beowulf (1932). Title page. Lithograph.

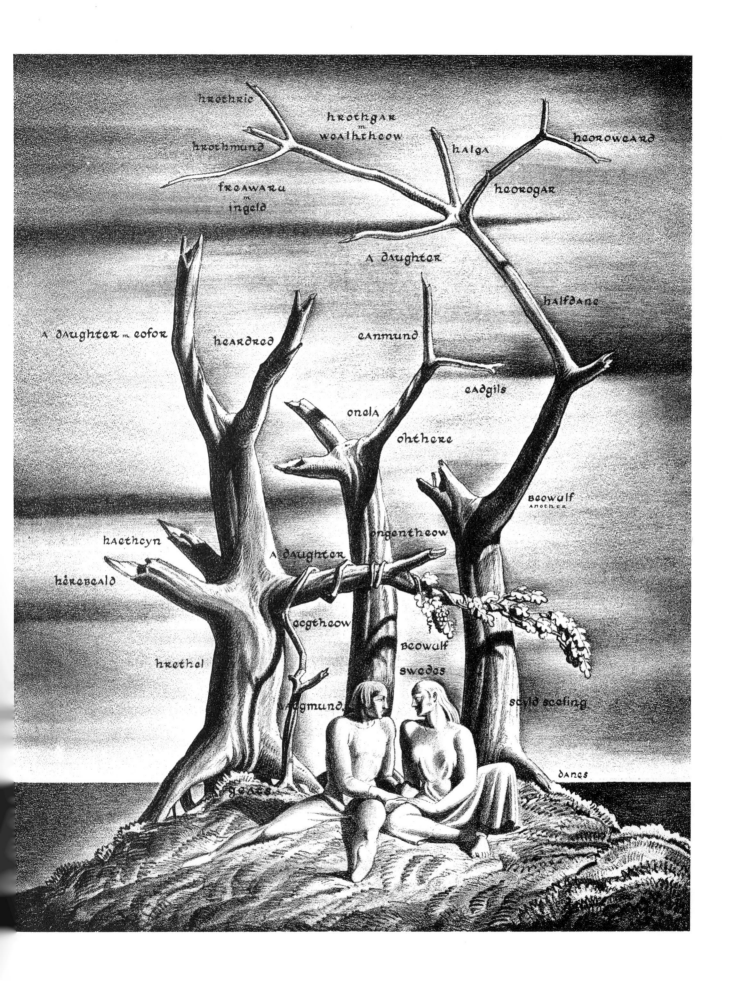

Beowulf (1932). Genealogical Tree. Lithograph.

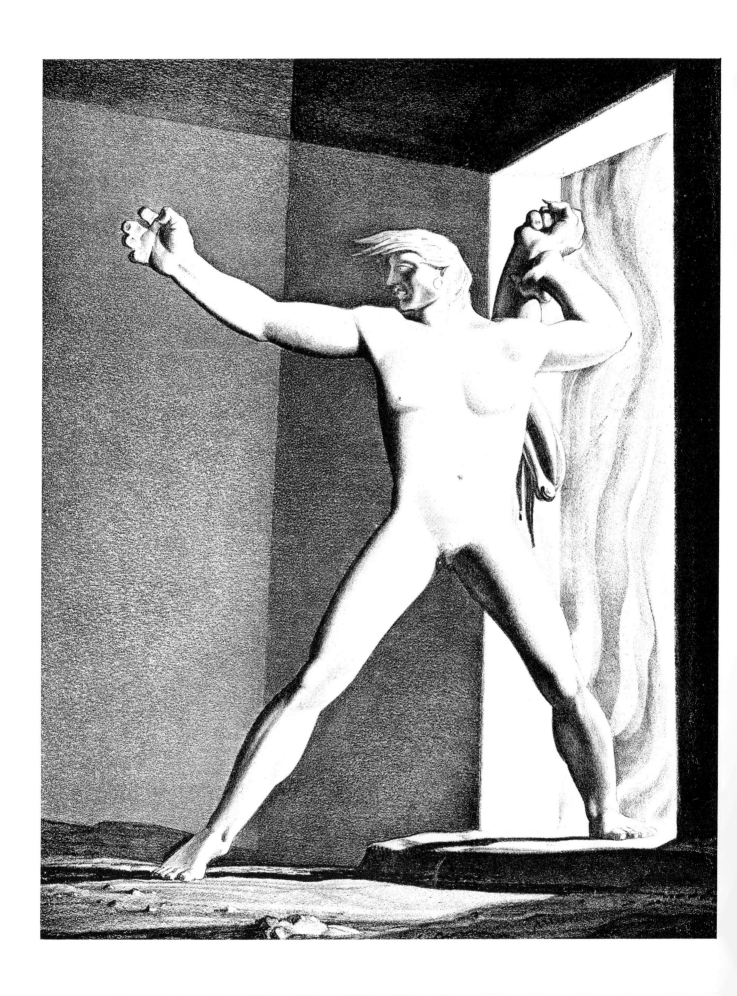

Beowulf (1932). Beowulf in a Rage. Lithograph.

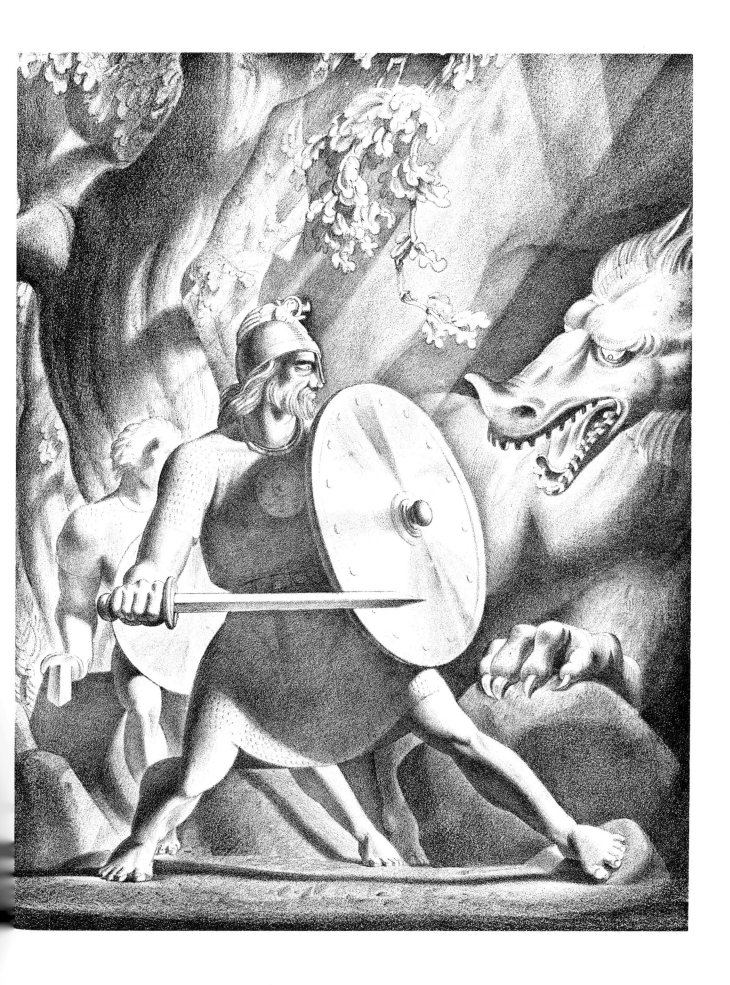

Beowulf (1932). Beowulf and the Dragon. Lithograph.

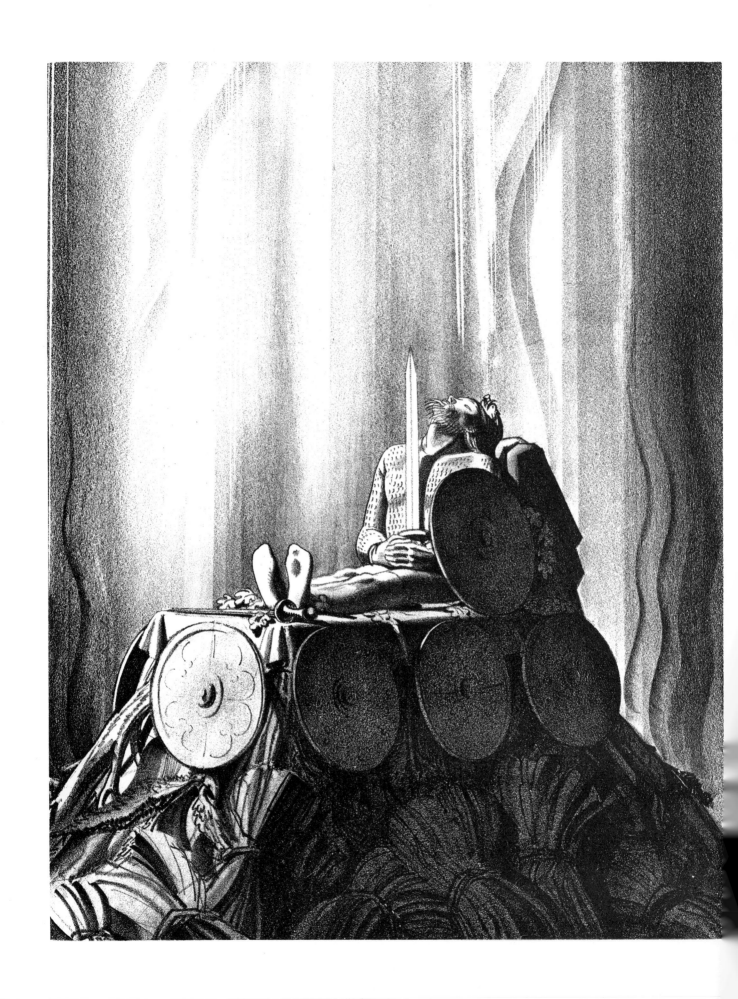

Beowulf (1932). Beowulf on the Funeral Pyre. Lithograph.

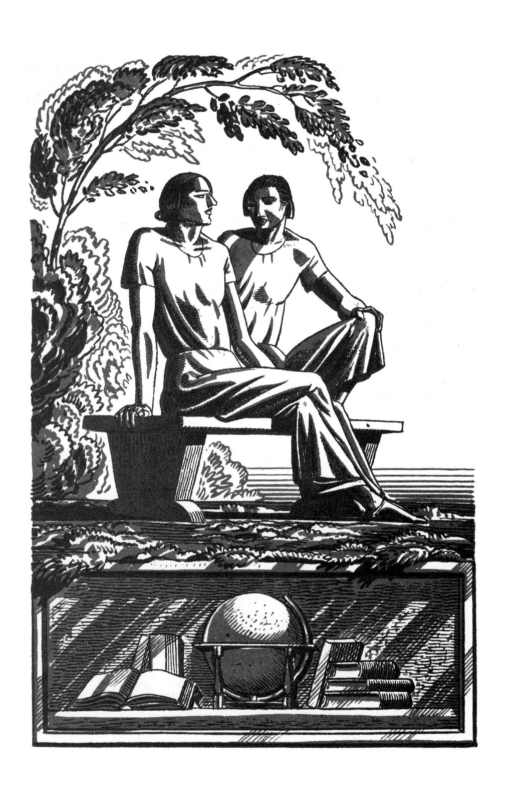

Erewhon (1934). Illustration, printed in blue and violet, for Chapter XIX, "The World of the Unborn."

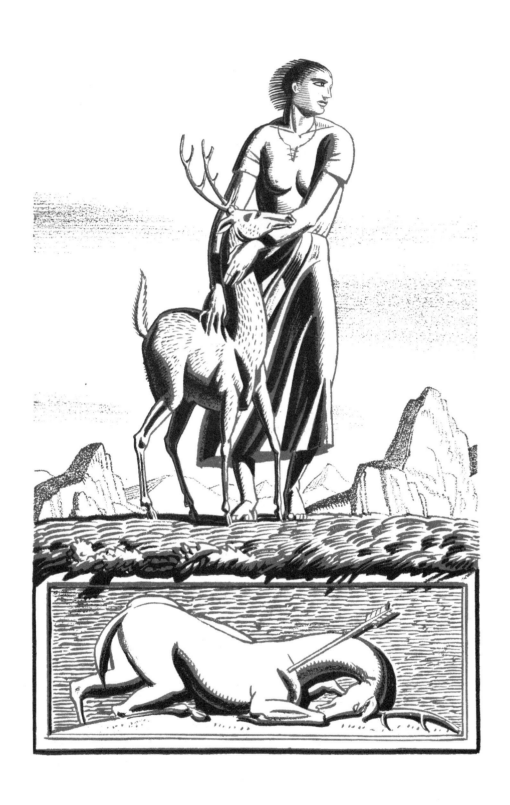

Erewhon (1934). Illustration, printed in blue and bistre, for Chapter XXV, "The Book of the Machine."

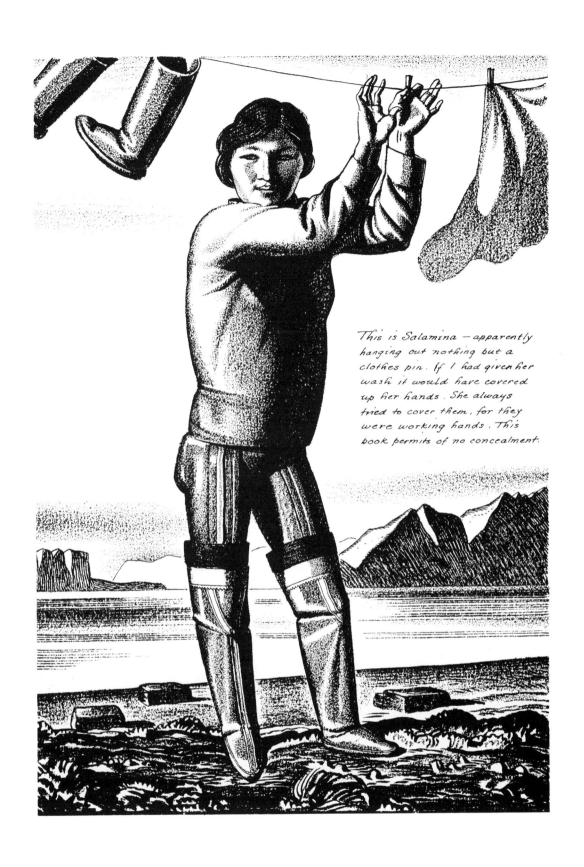

This is Salamina — apparently
hanging out nothing but a
clothes pin. If I had given her
wash it would have covered
up her hands. She always
tried to cover them, for they
were working hands. This
book permits of no concealment.

Salamina (1935). Frontispiece—Salamina. Illustration drawn in crayon and India ink and printed in brown ink.

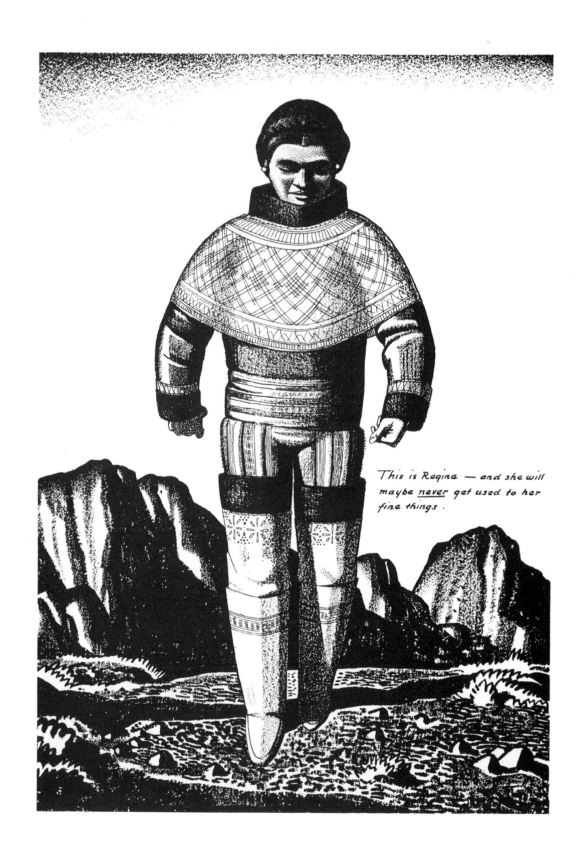

This is Regina — and she will maybe *never* get used to her fine things .

Salamina (1935). Regina. Illustration drawn in crayon and India ink on coarse-grained paper and printed in brown ink.

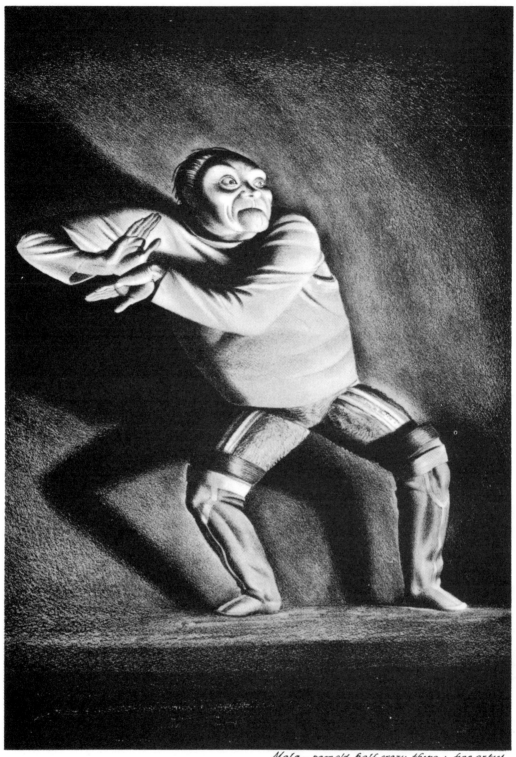

Mala – poor old half crazy thing ; fine artist

Salamina (1935). Mala. Lithograph printed in brown ink. 65

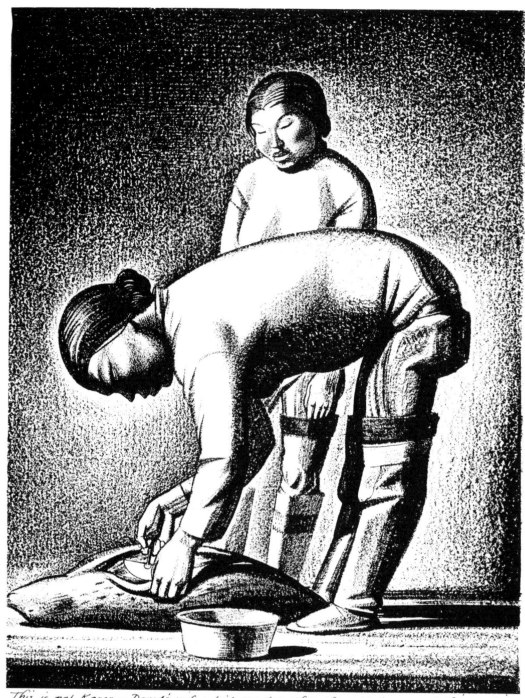

This is not Karen — David's wife; but one day when she was doing just this — skinning a seal which her accomplished husband had brought home — she was drawn away by some excitement on the shore, ran out, and — left the door open. Within sixty seconds there were sixty dogs inside. Men came up on the run, with clubs; they waded in, waist deep in dogs. For full ten minutes they were pitching dogs outdoors.

Salamina (1935). Not Karen. Illustration drawn in crayon and India ink on coarse-grained paper and printed in brown ink.

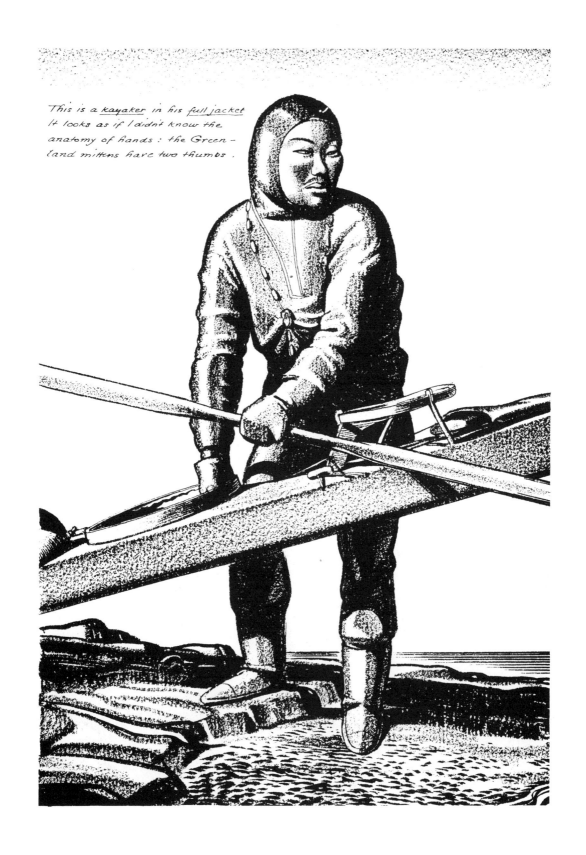

*This is a kayaker in his full jacket
It looks as if I didn't know the
anatomy of hands : the Green-
land mittens have two thumbs .*

Salamina (1935). Full Jacket. Illustration drawn in crayon and India ink on coarse-grained paper and printed in brown ink.

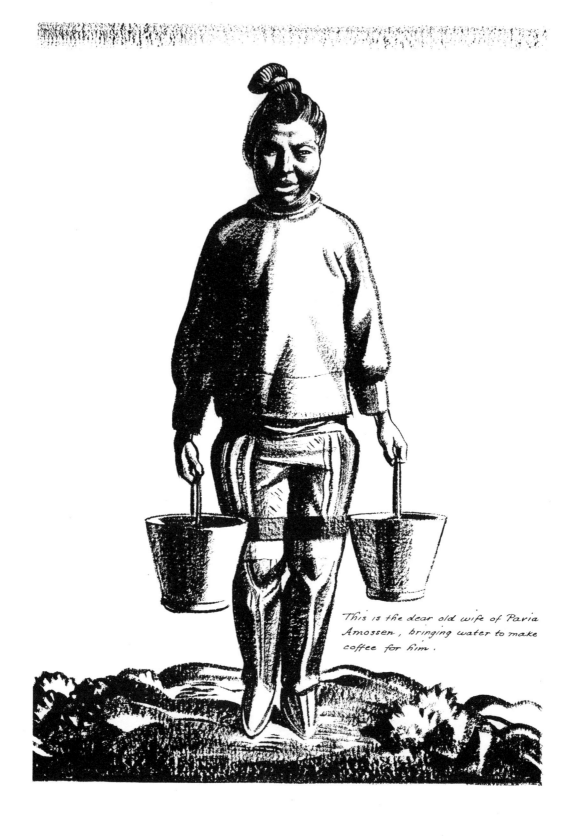

This is the dear old wife of Pavia Amossen, bringing water to make coffee for him.

Salamina (1935). Pavia's Wife. Illustration drawn in crayon and India ink on coarse-grained paper and printed in brown ink.

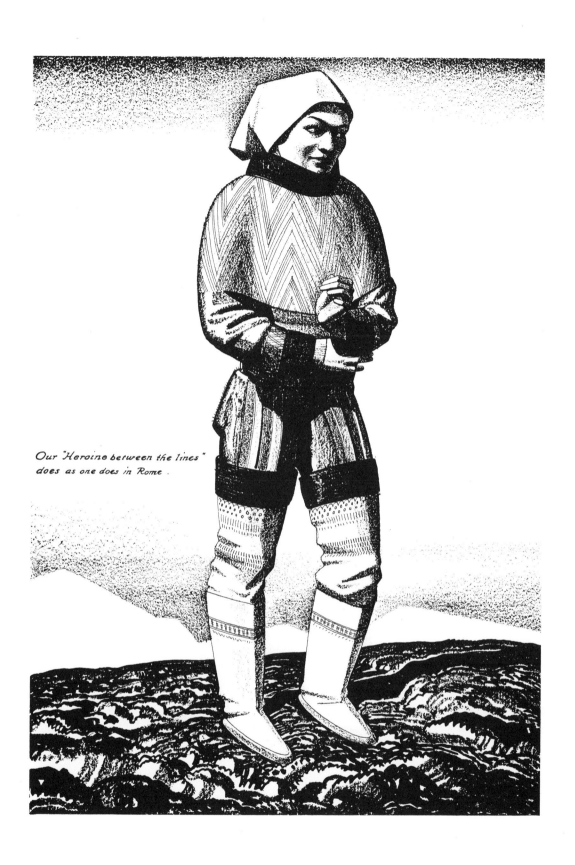

Our "Heroine between the lines" does as one does in Rome.

Salamina (1935). Blond Eskimo. Illustration drawn in crayon and India ink on coarse-grained paper and printed in brown ink.

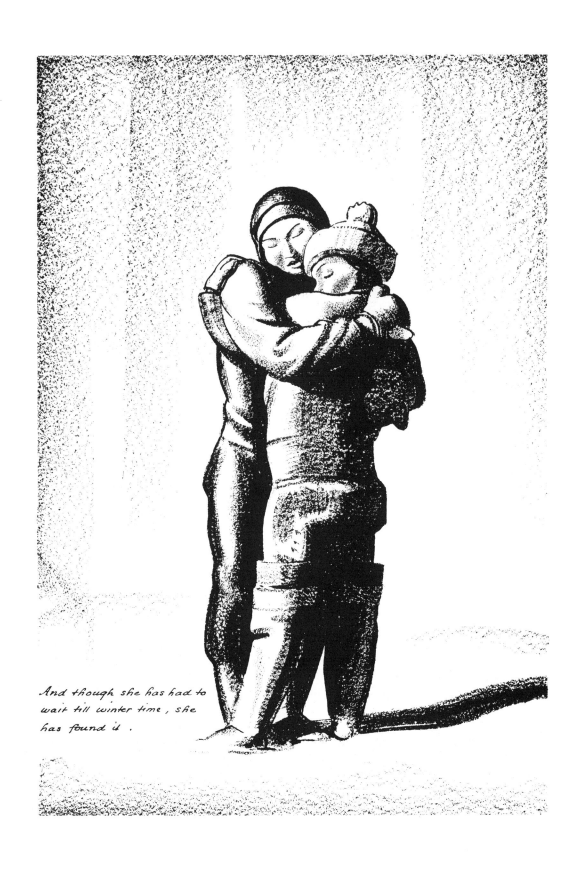

And though she has had to wait till winter time, she has found it .

Salamina (1935). Found. Illustration drawn in crayon and India ink on coarse-grained paper and printed in brown ink.

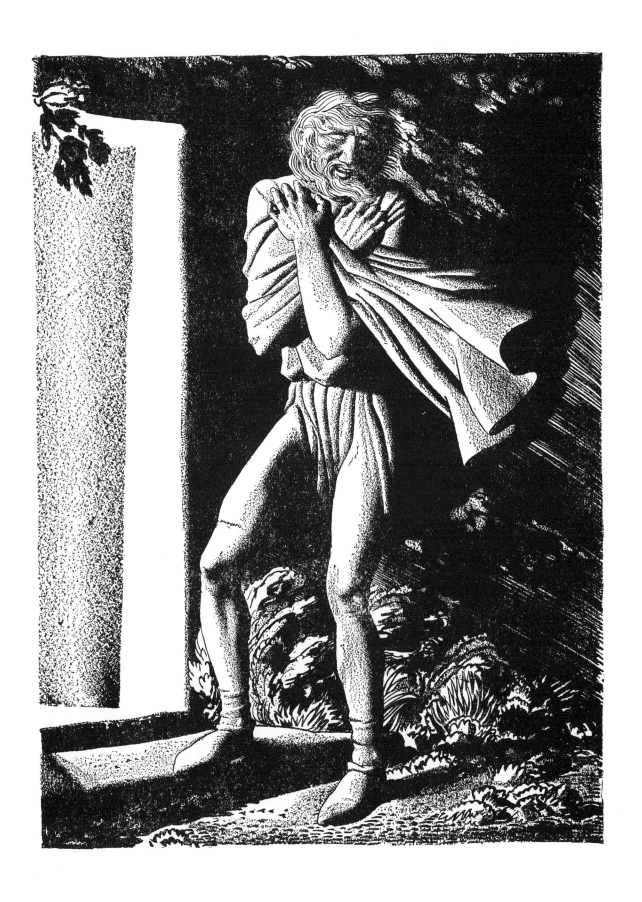

The Complete Works of William Shakespeare (1936). *King Lear.* "Blow, winds, and crack your cheeks! rage! blow!" Illustration drawn in crayon and India ink on coarse-grained paper.

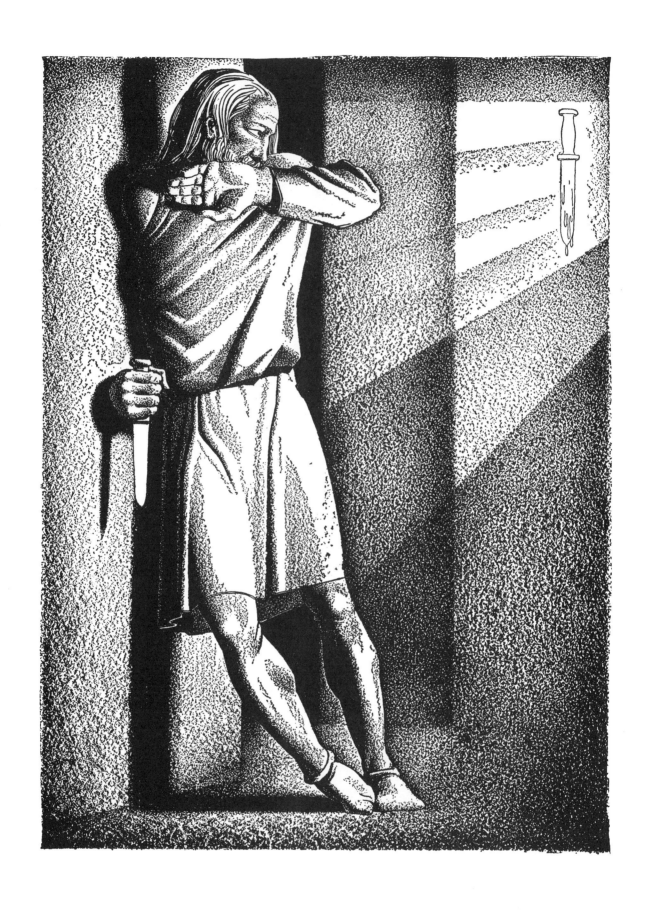

The Complete Works of William Shakespeare (1936). *Macbeth.* "Is this a dagger which I see before me?" Illustration drawn in crayon and India ink on coarse-grained paper.

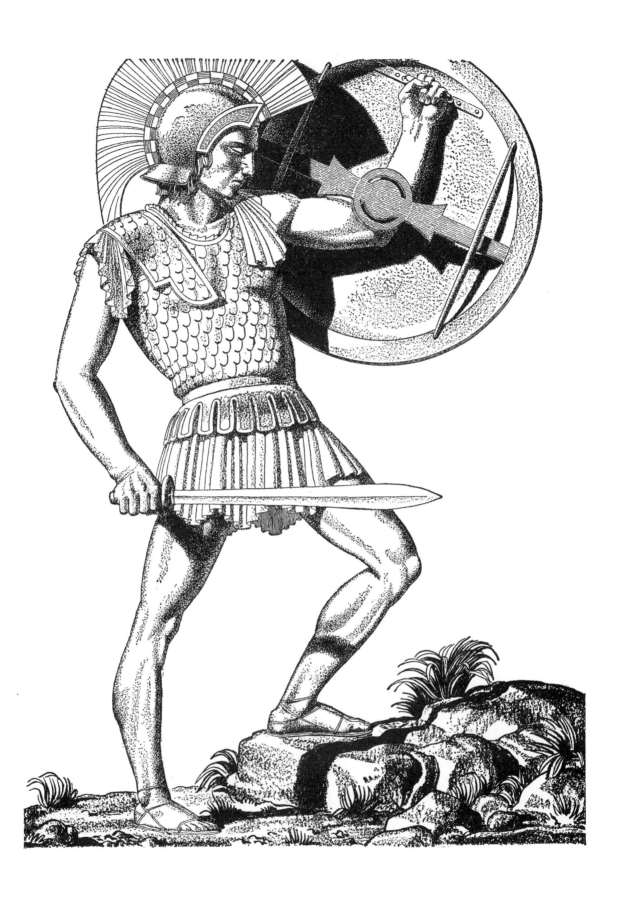

The Complete Works of William Shakespeare (1936). *Troilus and Cressida.* *"'Tis Troilus! there's a man!"* Illustration drawn in crayon and India ink on coarse-grained paper.

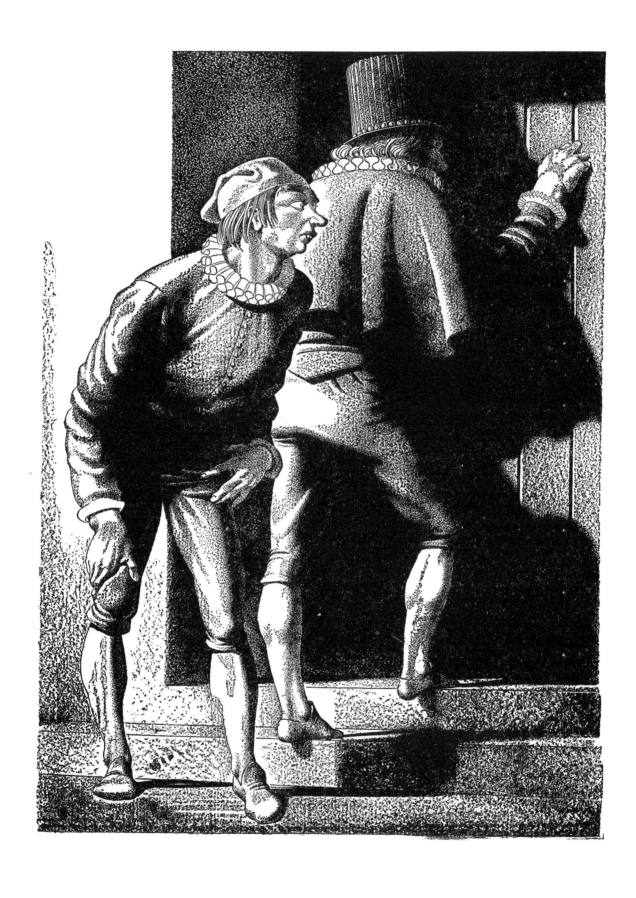

The Complete Works of William Shakespeare (1936). *The Comedy of Errors.* "Who talks within there? ho! open the door." Illustration drawn in crayon and India ink on coarse-grained paper.

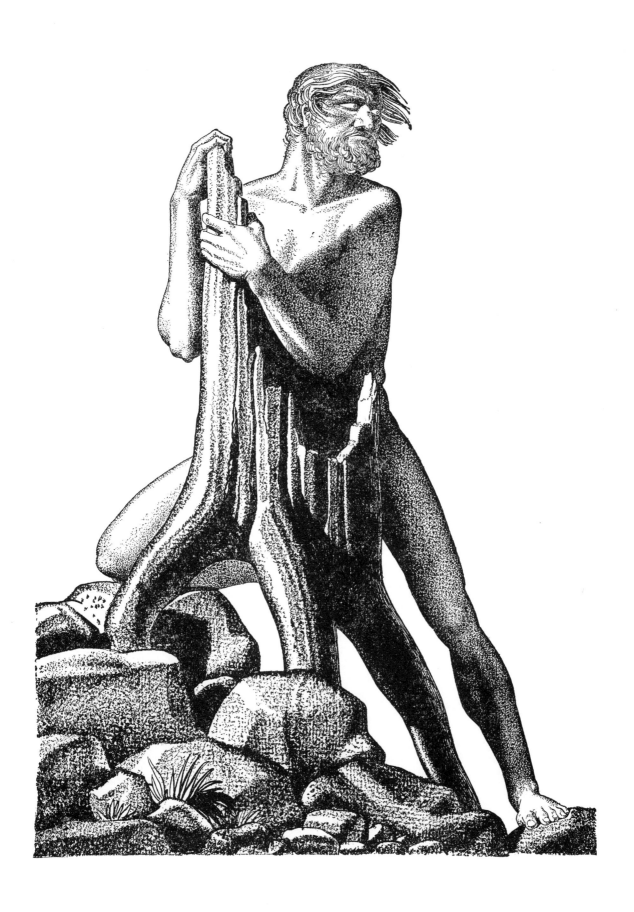

The Complete Works of William Shakespeare (1936). *Timon of Athens.* "Let me look back upon thee, O thou wall." Illustration drawn in crayon and India ink on coarse-grained paper.

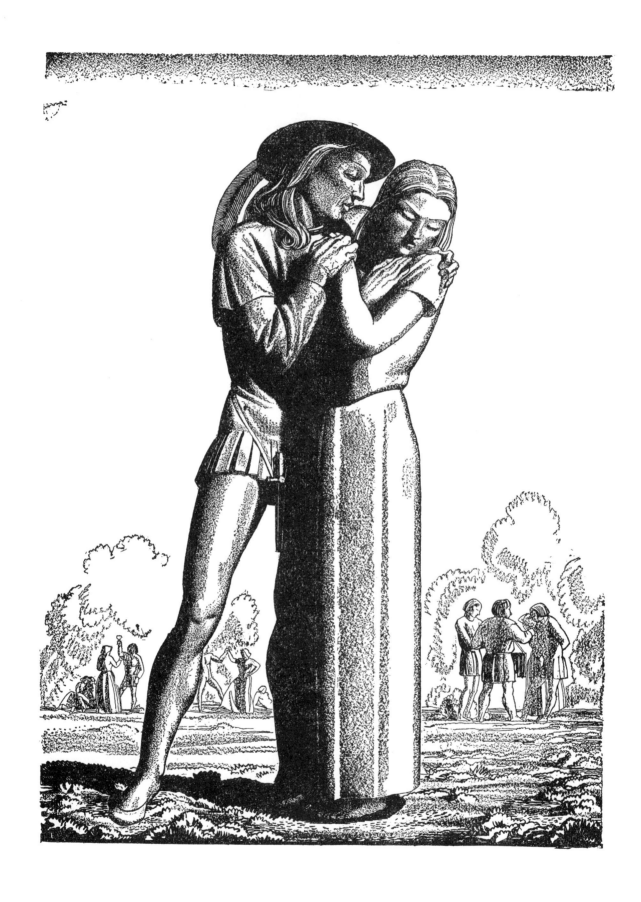

The Complete Works of William Shakespeare (1936). *The Winter's Tale.* "He tells her something / That makes her blood look out." Illustration drawn in crayon and India ink on coarse-grained paper.

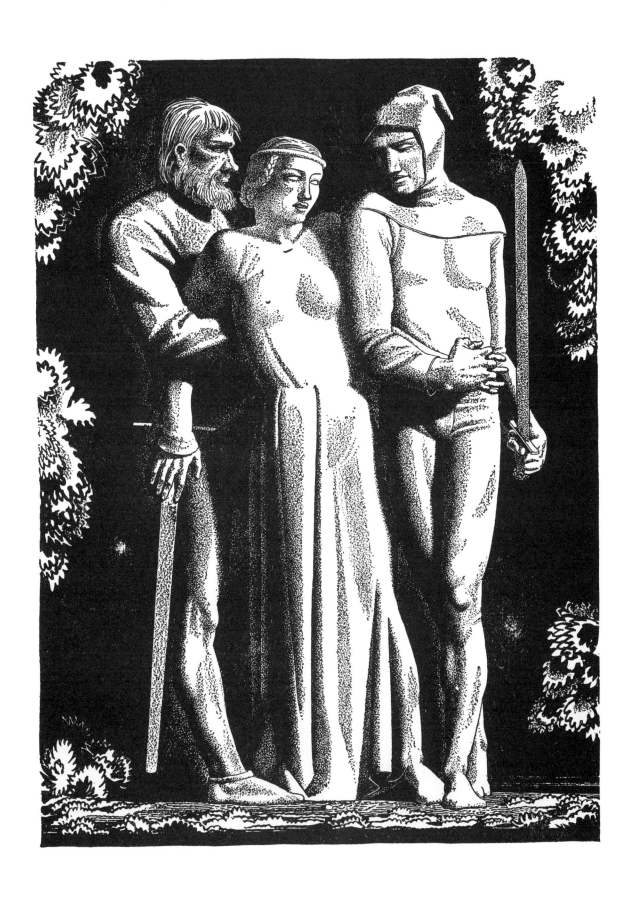

The Complete Works of William Shakespeare (1936). *The Two Gentlemen of Verona.*
"Come, come, / Be patient; we must bring you to our captain." Illustration drawn in
crayon and India ink on coarse-grained paper.

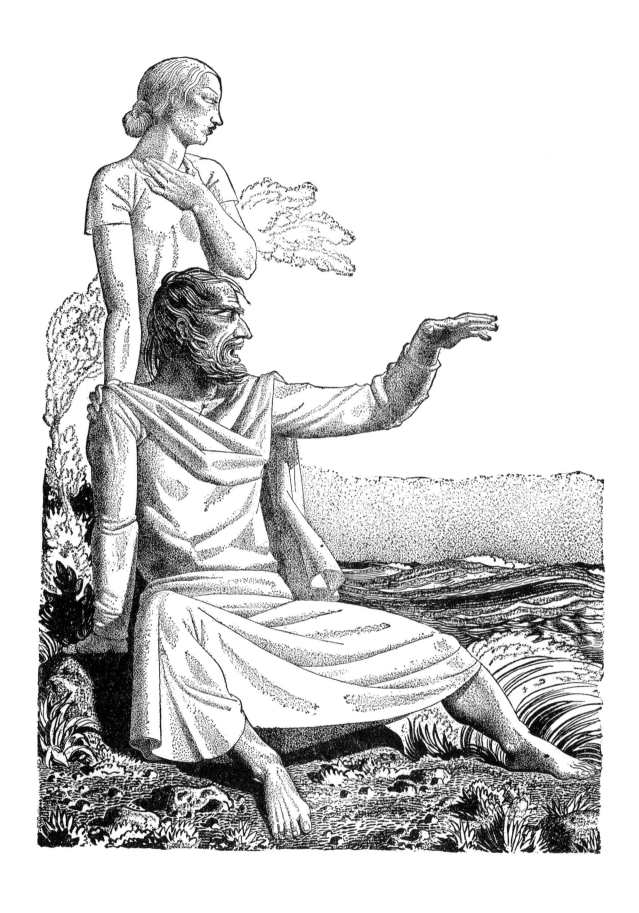

The Complete Works of William Shakespeare (1936). *The Tempest.* "I have done nothing but in care of thee." Illustration drawn in crayon and India ink on coarse-grained paper.

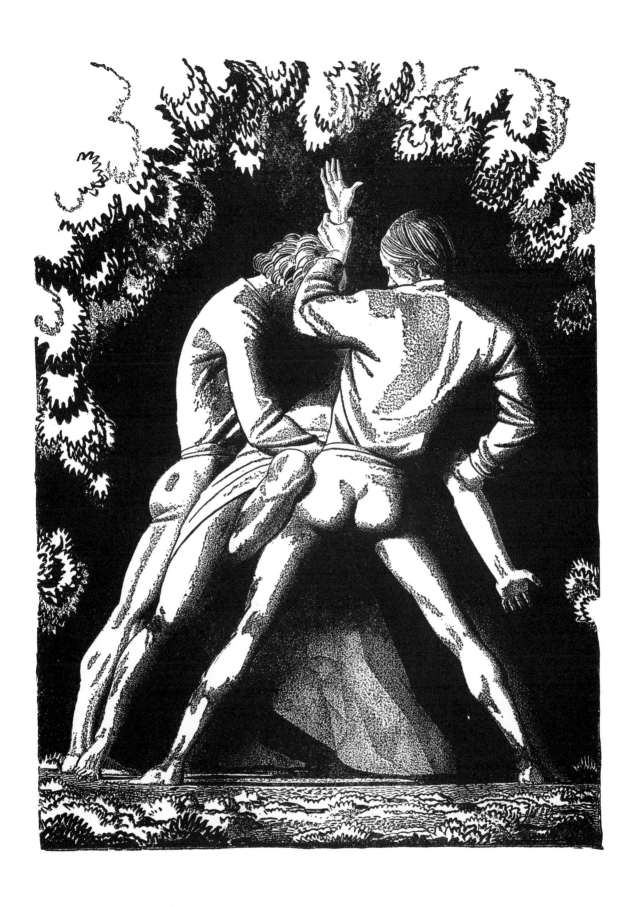

The Complete Works of William Shakespeare (1936). *Titus Andronicus.* "Confusion fall." Illustration drawn in crayon and India ink on coarse-grained paper.

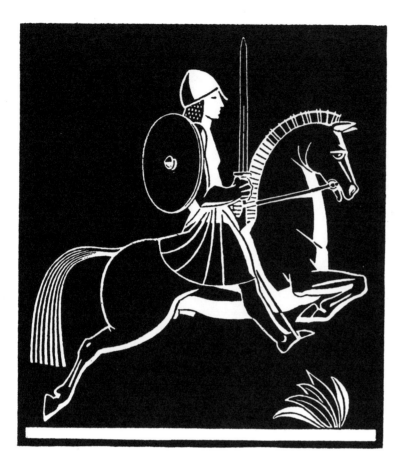

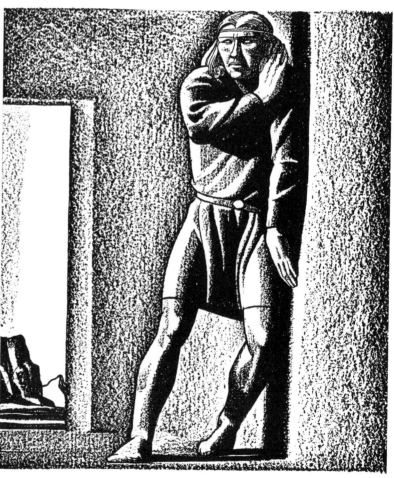

The Saga of Gisli (1936). TOP: Jacket Design. BOTTOM: "He went into the women's quarters because he heard voices coming therefrom." Illustration drawn in crayon and India ink on coarse-grained paper.

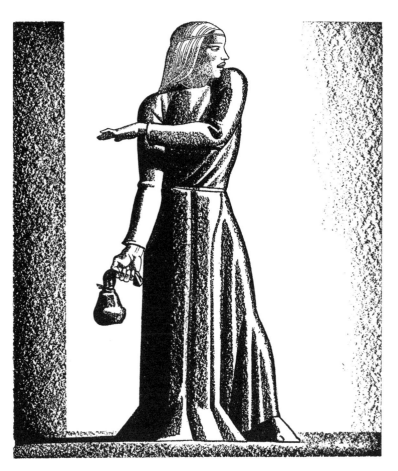

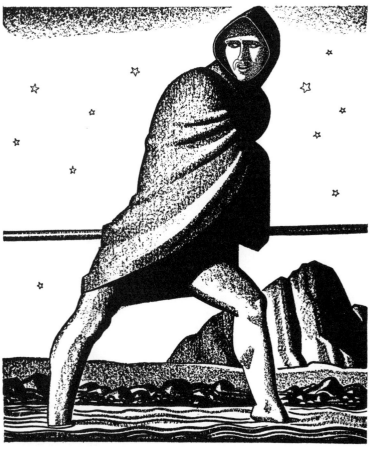

The Saga of Gisli (1936). TOP: "Aud thereupon took the silver and put it into a great moneybag." BOTTOM: "He followed his own path to the brook." Illustrations drawn in crayon and India ink on coarse-grained paper.

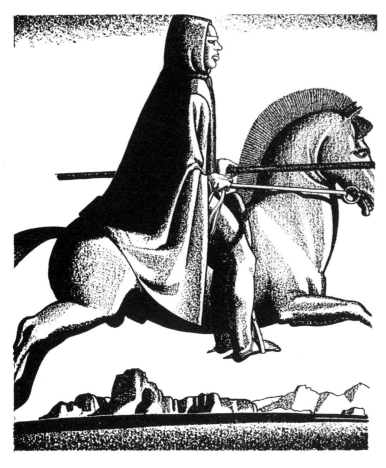

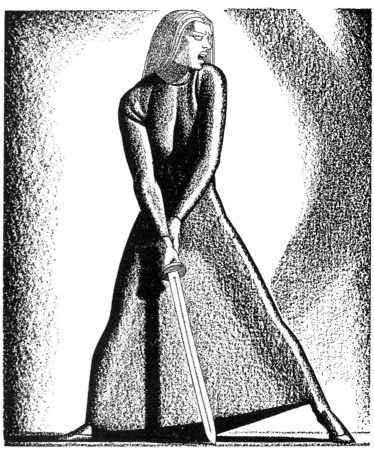

The Saga of Gisli (1936). TOP: "Now Vestan had already ridden from his home."
BOTTOM: "Thordis recognized the weapon . . . and suddenly snatched it up." Illustrations
drawn in crayon and India ink on coarse-grained paper.

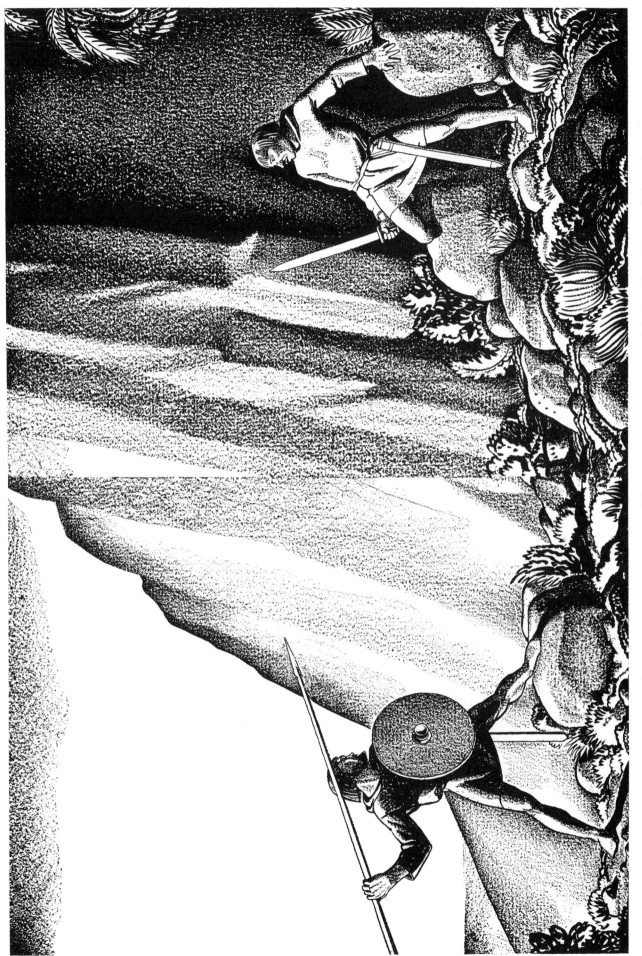

The Saga of Gisli (1936). "When he came into the cleft between the crags, Gisli stood facing him with sword drawn." Illustration drawn in crayon and India ink on coarse-grained paper.

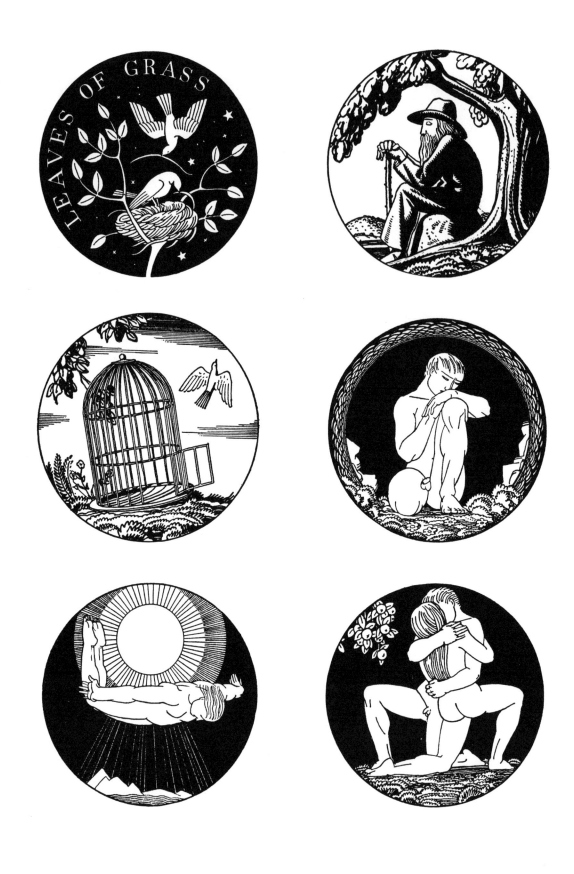

Leaves of Grass (1937). Half-title Mark and Headpieces for Poems. TOP LEFT: Half-title Mark. TOP RIGHT: "Sands at Seventy." MIDDLE LEFT: "Good-bye My Fancy." MIDDLE RIGHT: "Calamus." BOTTOM LEFT: "Salut au Monde!" BOTTOM RIGHT: "Children of Adam."

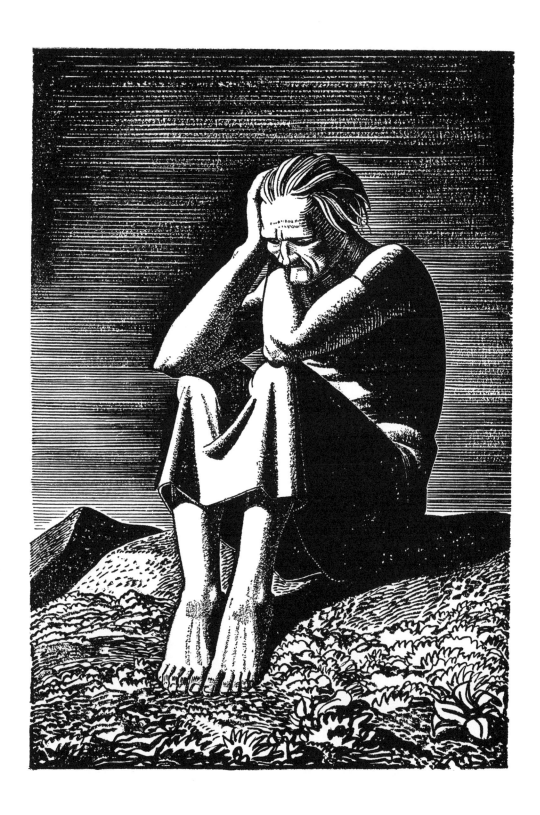

This is My Own (1940). "World, O Life, O Time—"

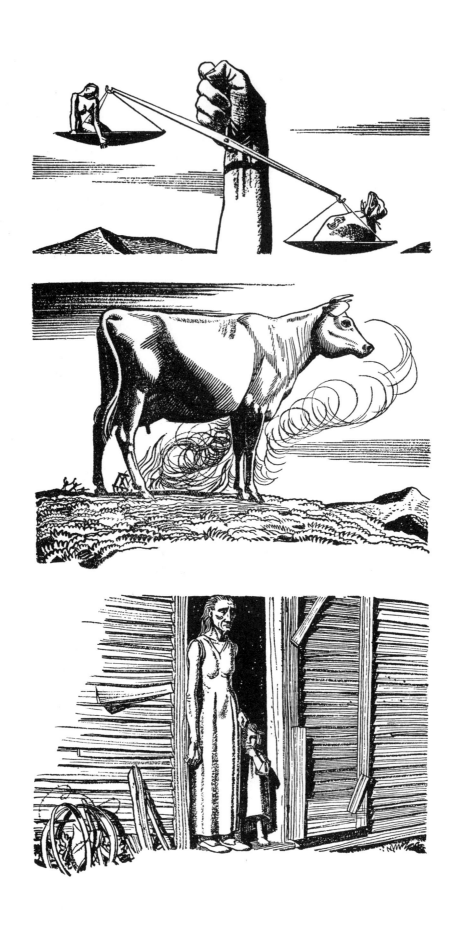

This is My Own (1940). TOP TO BOTTOM: "Then take thy bond, take thou thy pound of flesh"; "Their barn and every last thing in it . . . had burned to ashes"; "In shacks

contrived of refuse from the city dumps."

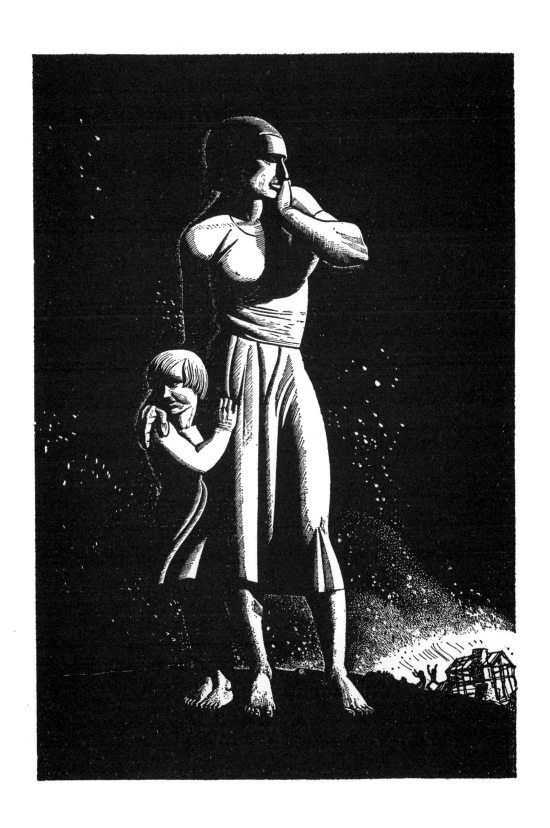

This is My Own (1940). In the Year of Our Lord.

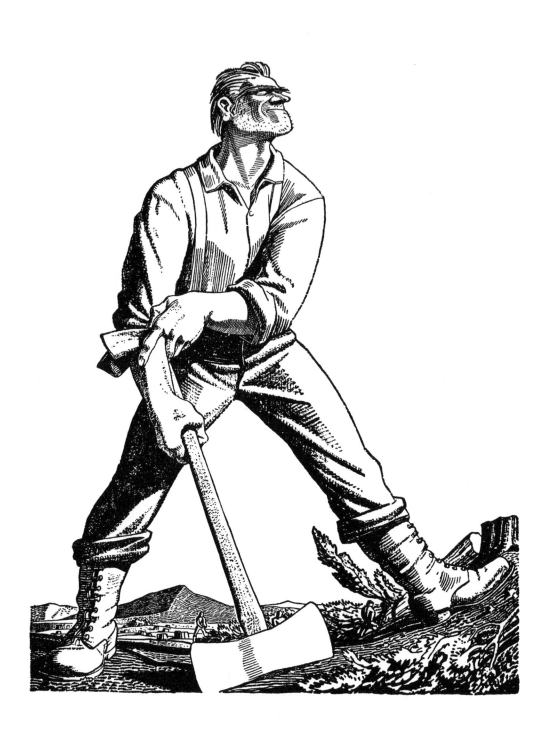

Paul Bunyan (1941). Frontispiece—"And he was a great logger, that's sure—and I guess there ain't nobody pretends there ever was anybody like him . . ."

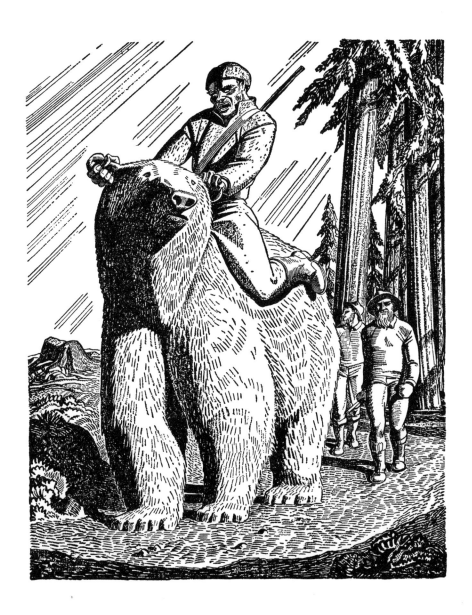

Paul Bunyan (1941). "Must of in the fight got mixed up someway."

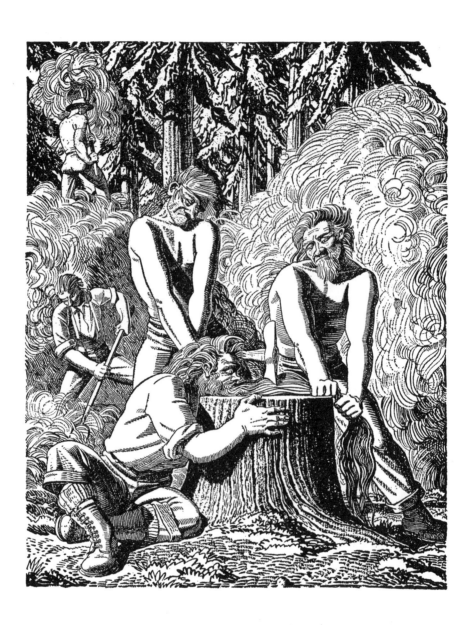

Paul Bunyan (1941). "We used our axes for the first few cuts."

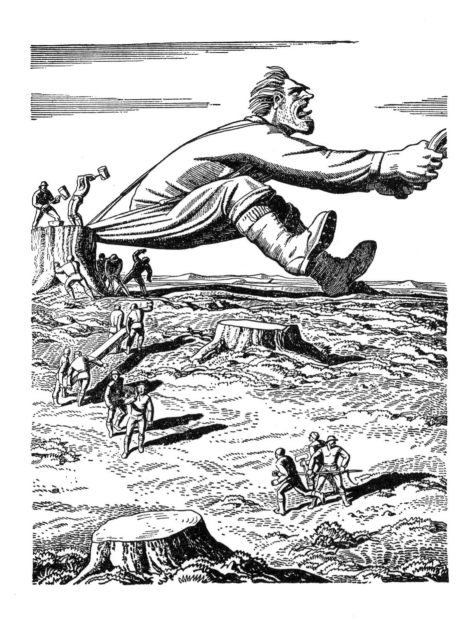

Paul Bunyan (1941). "And there he was, stuck fast."

Paul Bunyan (1941). "Paul was all broke up."

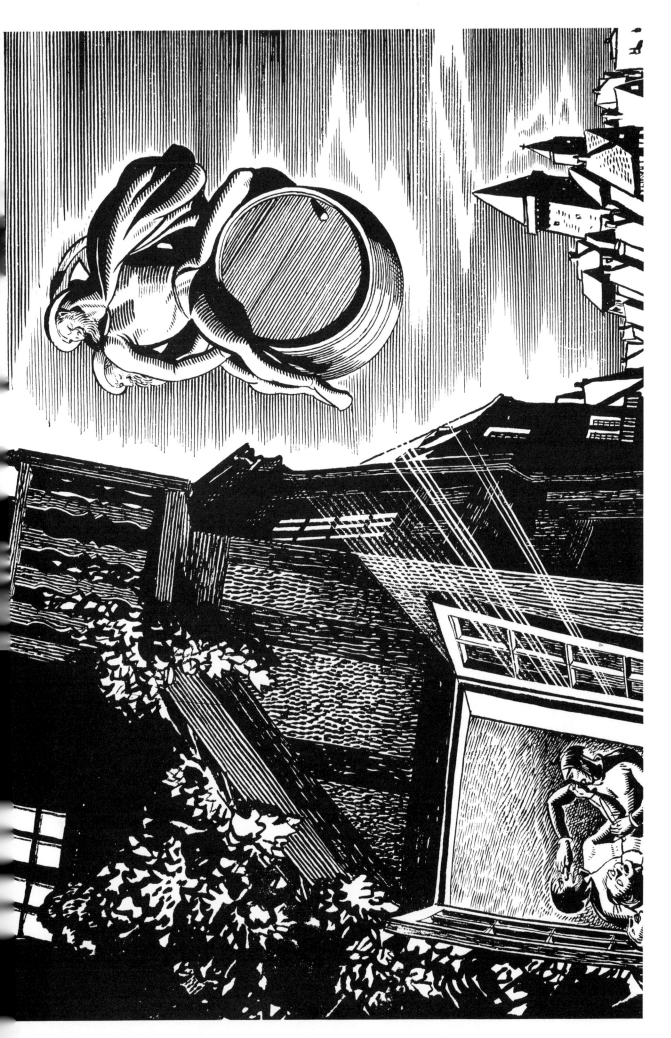

Goethe's Faust (1941). Auerbach's Cellar in Leipsic. Mephistopheles: "Illusion takes the veil from their eyes! / And you, see how the devil plays a trick!"

Goethe's *Faust* (1941). Night in the Street in Front of Gretchen's House. Mephistopheles: "Now the fool's tamed! / But come! We've got to vanish."

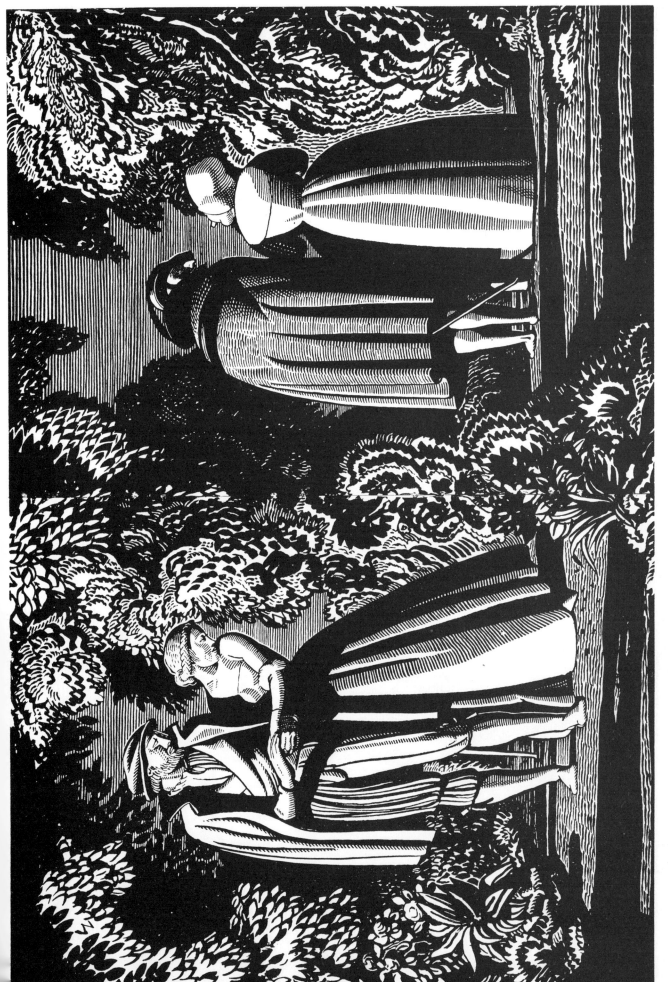

Goethe's Faust (1941). A Garden. Faust: "A glance, a word from you are worth / More than all the wisdom on the earth."

Goethe's Faust (1941). A Dungeon. Gretchen: "I give myself up to the judgment of God!"

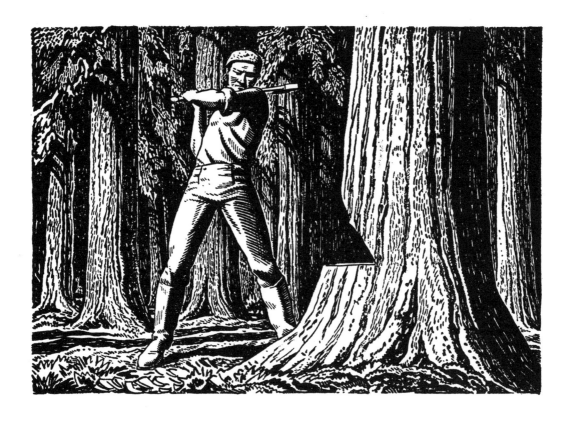

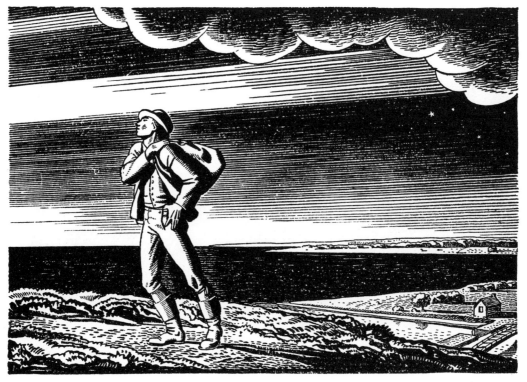

To Thee, America! (1946). TOP: "Out of the sweat of their brows, men ate their bread."
BOTTOM: "They must have had high courage and great faith in their own resourcefulness
and strength . . . to dare to still go on."

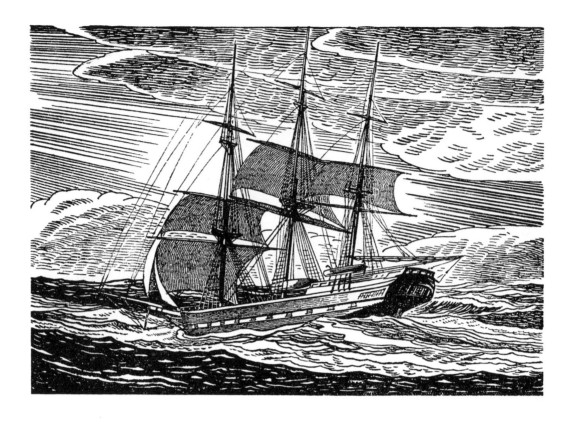

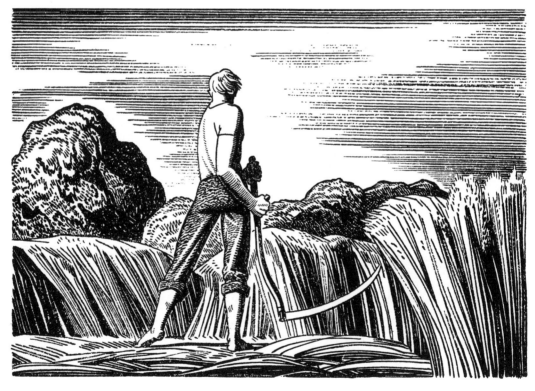

To Thee, America! (1946). TOP: "The still waters of the Narrows came at last to purr along the vessel's side." BOTTOM: "And barley is the body of malt."

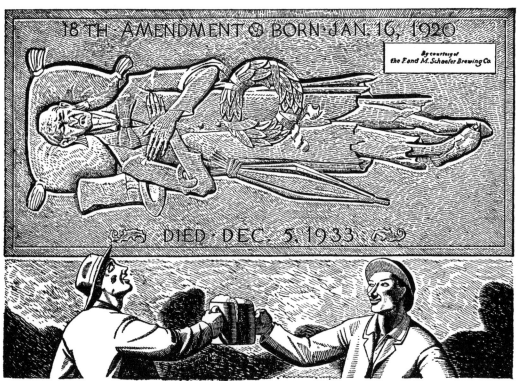

To Thee, America! (1946). TOP: "The inevitable and disastrous approach of Prohibition." BOTTOM: "1933: Repeal of Prohibition."

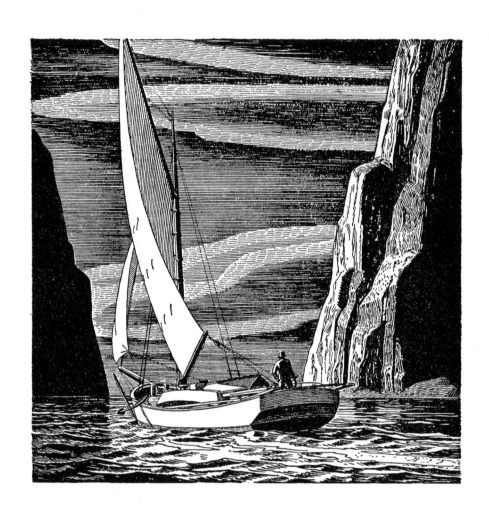

A Treasury of Sea Stories (1948). "Rounding the Horn," by Captain Joshua Slocum. "Still further to leeward was a headland, and I bore off for that."

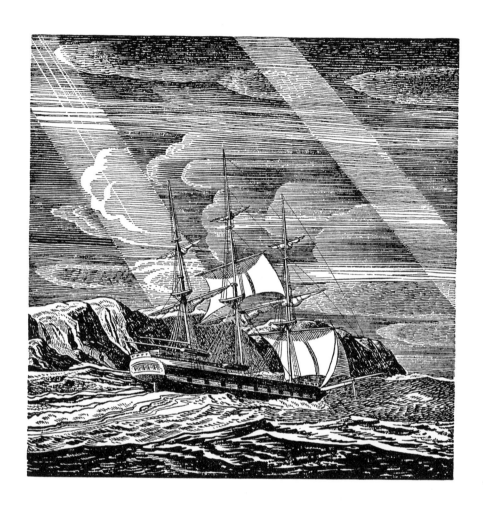

A Treasury of Sea Stories (1948). "The Horn," by Richard H. Dana, Jr. "It was a place well suited to stand at the junction of the two oceans."

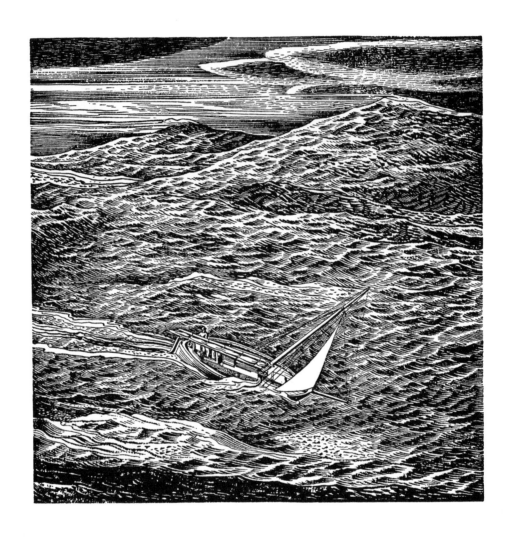

A Treasury of Sea Stories (1948). "The First Leg," (from *N by E*) by Rockwell Kent.
"At ten o'clock we shorten sail and are hove to under staysail."

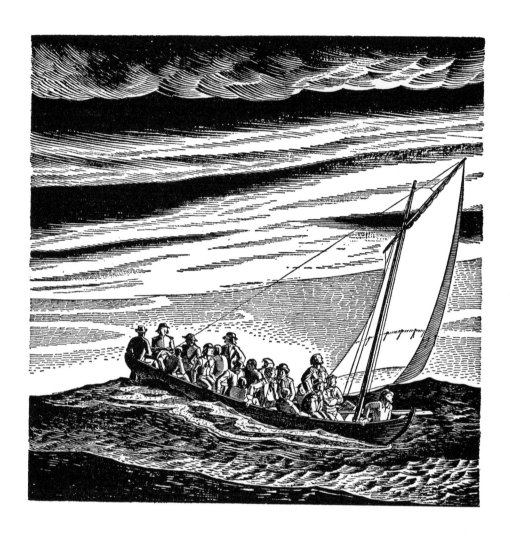

A Treasury of Sea Stories (1948). "A Narrative of the Mutiny on Board His Majesty's Ship Bounty," by Lieutenant William Bligh. "With a moderate easterly breeze which sprung up we were able to sail."

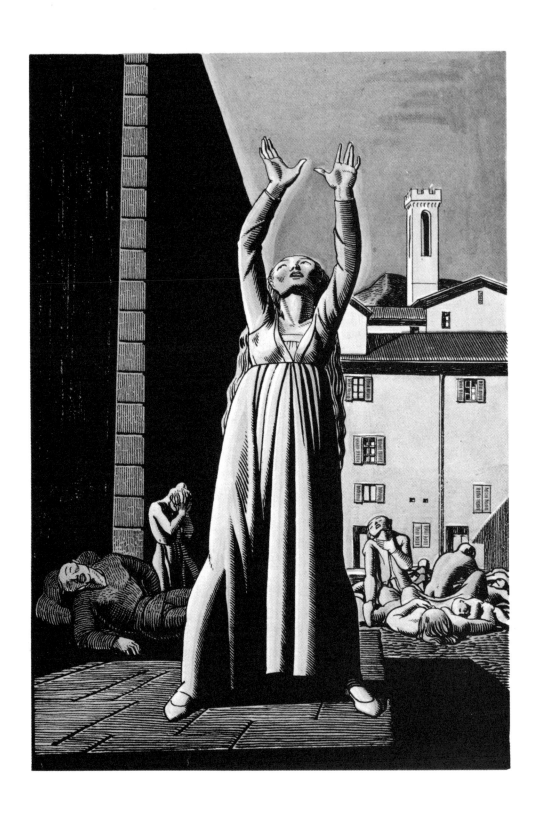

The Decameron of Giovanni Boccaccio (1949). "Many people died." Illustration in black line with tints in two colors.

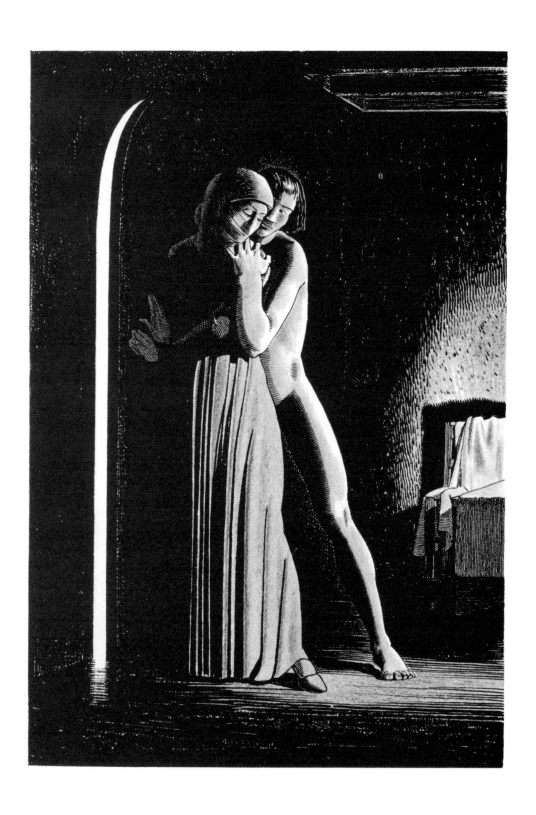

The Decameron of Giovanni Boccaccio (1949). "And locked the door." Illustration in black line with tints in two colors.

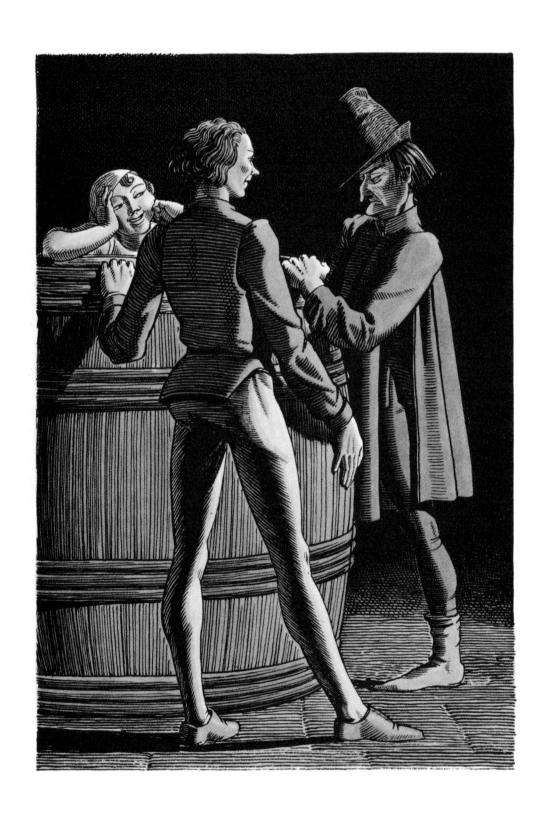

The Decameron of Giovanni Boccaccio (1949). "I won't take it unless I first see it
cleaned." Illustration in black line with tints in two colors.

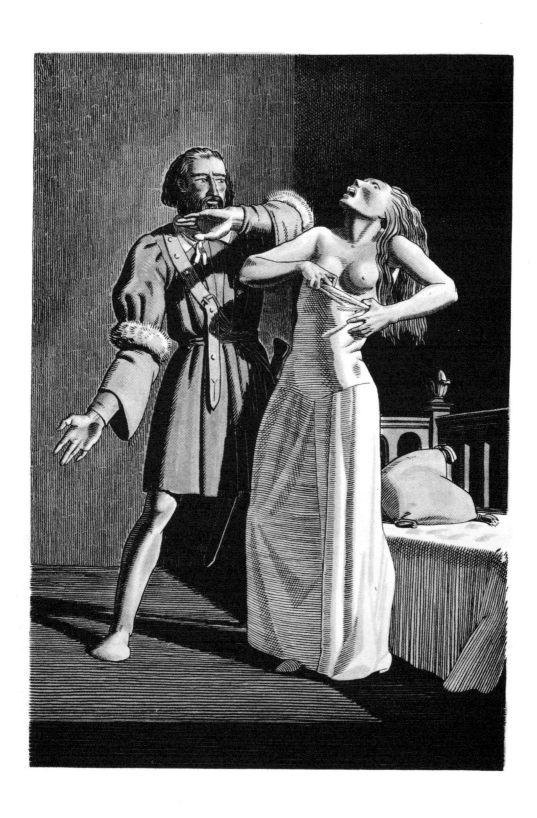

The Decameron of Giovanni Boccaccio (1949). "She . . . tore open her clothes." Illustration in black line with tints in two colors.

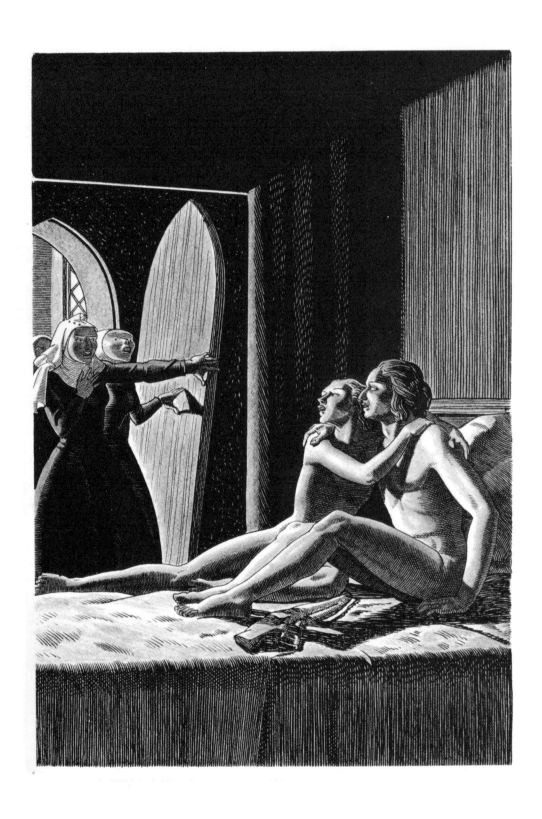

The Decameron of Giovanni Boccaccio (1949). "They found the two lovers." Illustration in black line with tints in two colors.

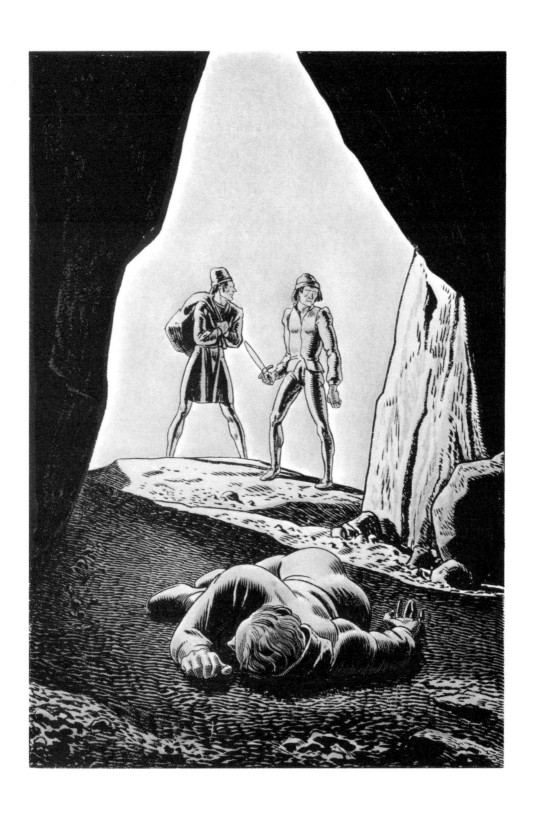

The Decameron of Giovanni Boccaccio (1949). "Two men had been thieving." Illustration in black line with tints in two colors.

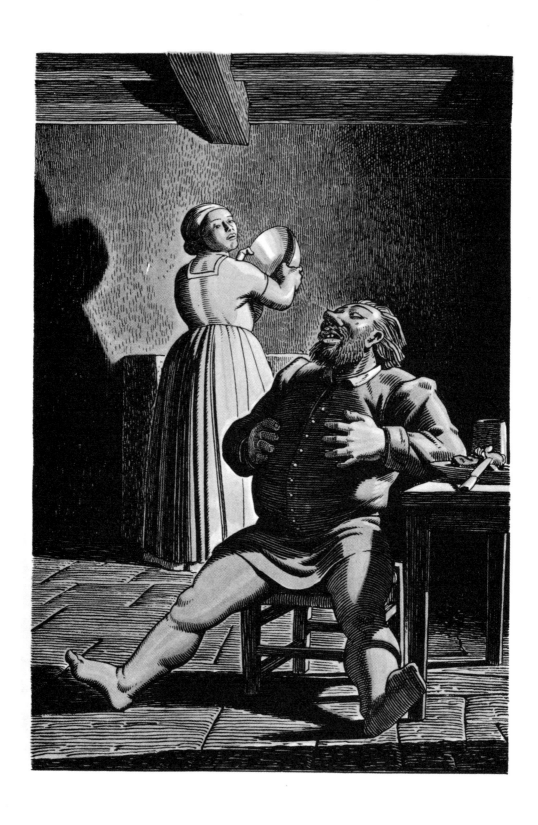

The Decameron of Giovanni Boccaccio (1949). "He told her he was a gentleman."
Illustration in black line with tints of two colors.

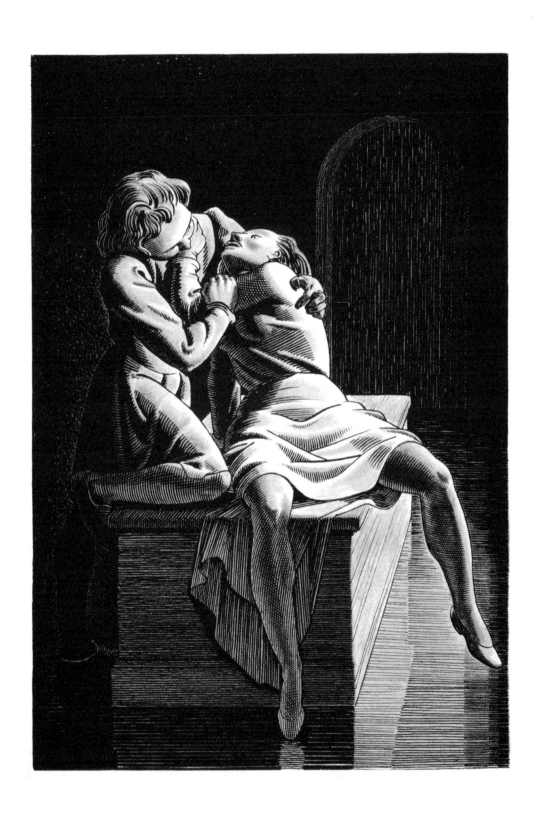

The Decameron of Giovanni Boccaccio (1949). "Laid her upon the chest." Illustration
in black line with tints of two colors.

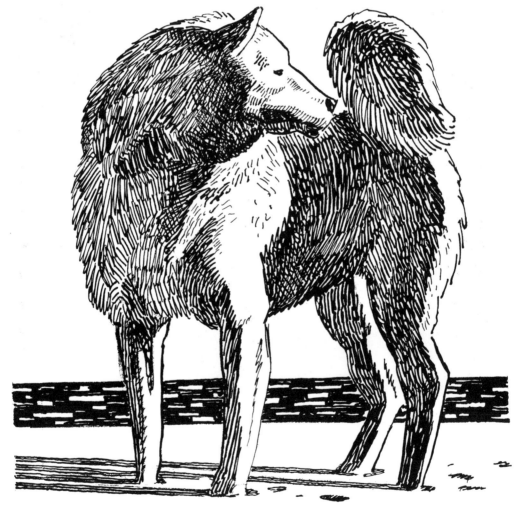

Rockwell Kent's Greenland Journal (1963). TOP: "Instead of boards to repair it he tore it down." BOTTOM: Greenland Dog.

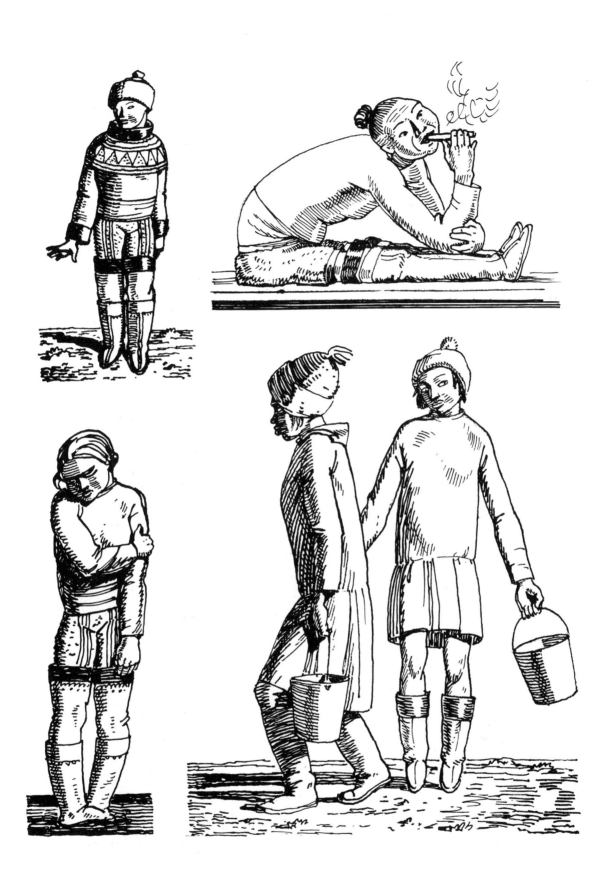

Rockwell Kent's Greenland Journal (1963). TOP LEFT: Cornelia. TOP RIGHT: Old Greenland Woman. BOTTOM LEFT: Pauline. BOTTOM RIGHT: Our Gift to Greenland Fashion.

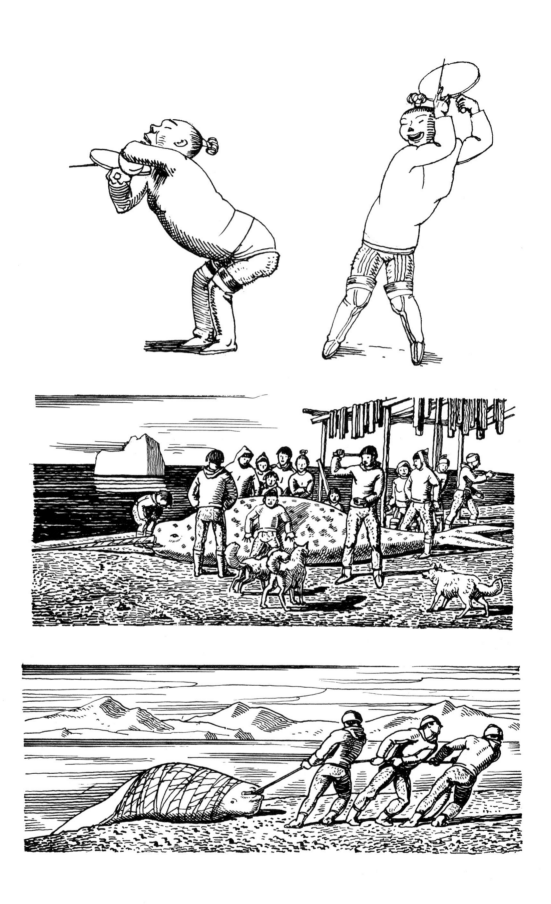

Rockwell Kent's Greenland Journal (1963). TOP TO BOTTOM: "Hup! Hup!"; The Narwhal; "They find a white whale in my net."

KATHERINE ABBOTT

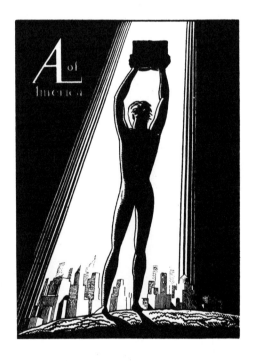

Bookplates. BOTTOM LEFT: Somerset Maugham. BOTTOM RIGHT: Authors of America.

Bookplates and Marks. RIGHT TOP: Elmer Adler. RIGHT MIDDLE: Hound & Horn.
RIGHT BOTTOM: Random House.

ELNITA STRAUS LIBRARY
COUNCIL HOUSE

RAYMOND DEXTER HAVENS

Bookplates. BOTTOM RIGHT: Estelle and Edwin Weiss.

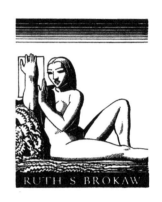

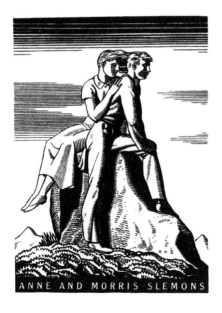

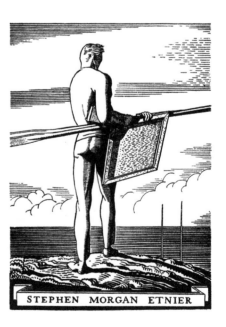

Bookplates and stamp. CENTER: Greenland airmail stamp.

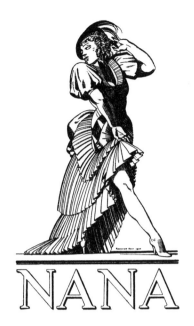

Bookplates and mark.

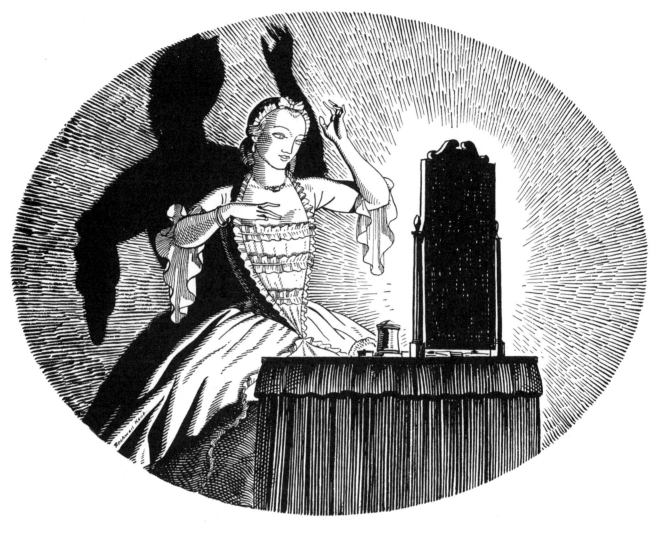

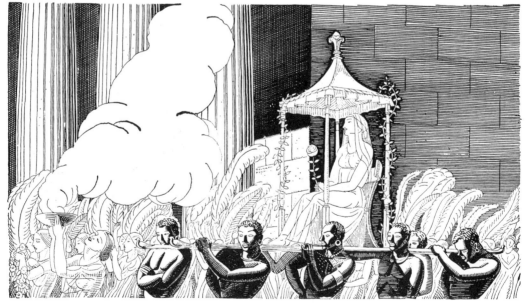

Advertising art (1927–29). Drawings for Marcus & Company.

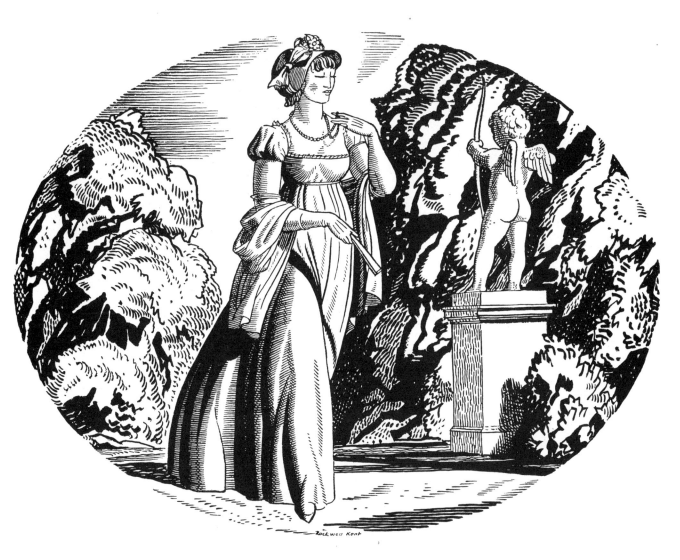

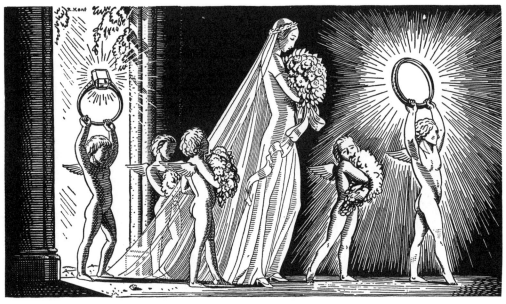

Advertising art (1927–29). Drawings for Marcus & Company.

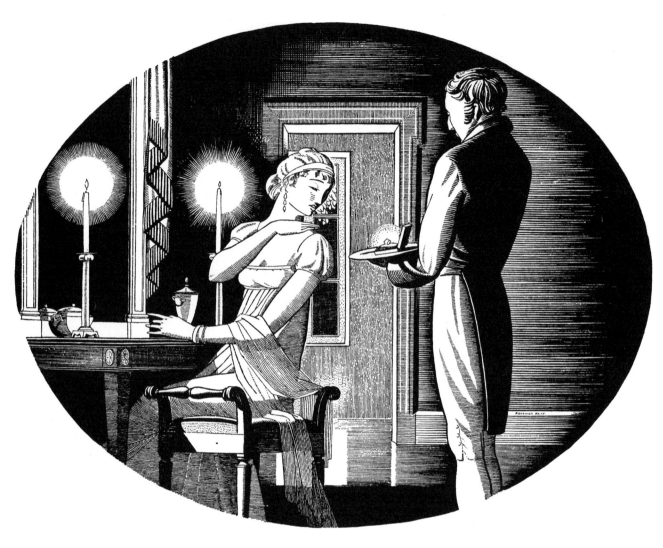

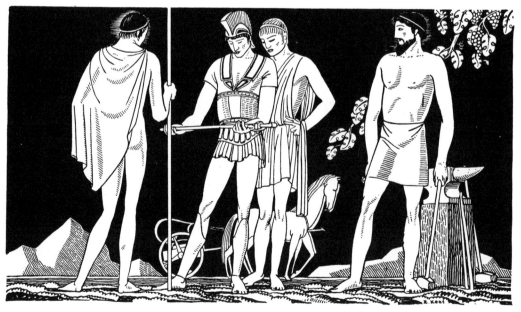

Advertising art (1927–29). Drawings for Marcus & Company.

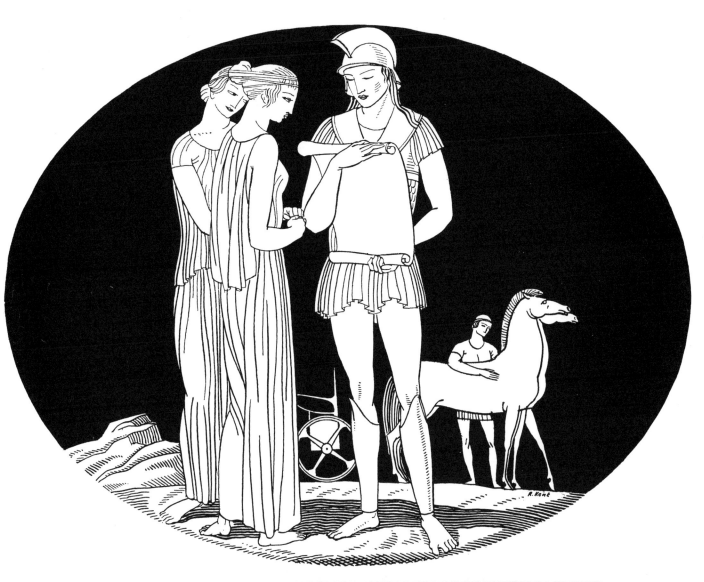

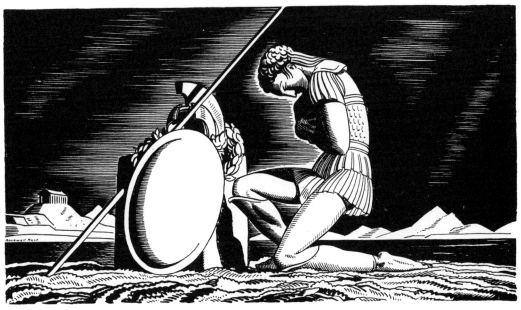

Advertising art (1927–29). Drawings for Marcus & Company. 123

Advertising art (1927). Drawing for Rolls Royce.

Advertising art (1927). Drawing for Rolls Royce.

Advertising art. One of a series drawn for *The Chicago Tribune*.

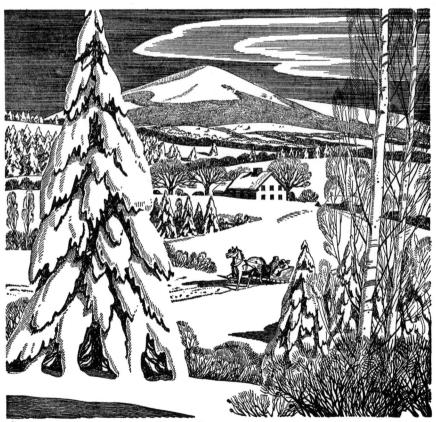

Advertising art. Two drawings for P.O.N. Beer.

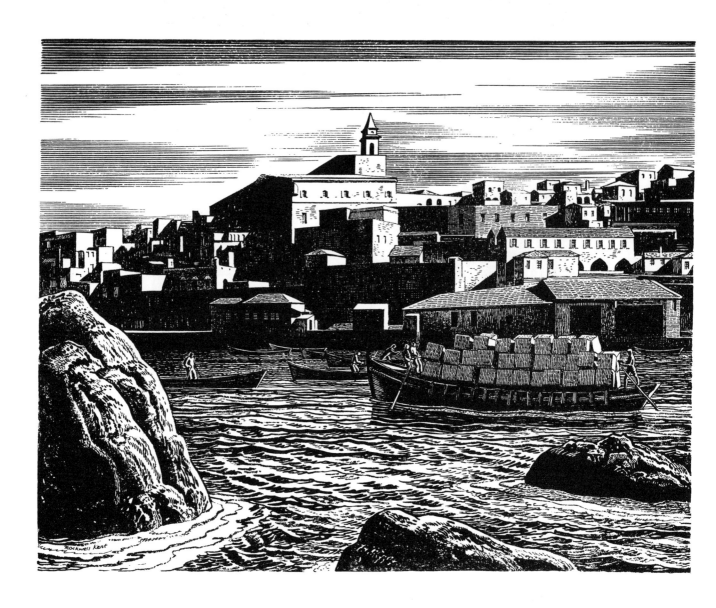

Advertising art (1946). *Jaffa*, drawn for American Export Lines.

Chronological List of Books
from Which Illustrations Have Been Reproduced

1914 *Architectonics, The Tales of Tom Thumtack,* (Frederick Squires), The William T. Comstock Company, New York, 1914. 8vo. Bound in decorative cloth. 174 pages, 85 illustrations, besides initial letters, by Rockwell Kent. The artist's name does not appear in the book.

1920 *Wilderness: A Journal of Quiet Adventure in Alaska,* By Rockwell Kent, With Drawings by the Author and an Introduction by Dorothy Canfield. G. P. Putnam's Sons, New York, and London, The Knickerbocker Press, 1920. 4to. Bound in gray linen with gold stamping. 240 pages, 64 illustrations and decorative end papers. Second printing, 1924; third printing, 1927. Reset for 8vo edition of the Modern Library in 1930. Subsequent reprints, including German edition.

1924 *A Basket of Poses,* Verses by George S. Chappell; Pictures by Hogarth, Jr. (Rockwell Kent), Albert & Charles Boni, New York, 1924. 4to. Bound in decorated boards with paper label. 112 pages, 48 illustrations by Hogarth, Jr.

1924 *Voyaging Southward from the Strait of Magellan,* By Rockwell Kent, With Illustrations by the Author, New York & London, G. P. Putnam's Sons, The Knickerbocker Press, 1924. 4to. Bound in tan buckram with decorative stamping. 204 pages. 100 illustrations and decorated end papers. Also an edition de luxe, bound in blue paper, limited to 110 copies, signed and numbered, with additional original signed woodcut in two colors. Second printing, 1924; third printing, 1926. Reprint, 1936.

1927 *Dreams and Derisions,* Nineteen Hundred Twenty-seven. 4to. Bound in brown half morocco with marbled paper sides. 100 pages. 64 illustrations and decorations, printed in brown ink. Privately printed by Pynson Printers for John Burke (Ralph Pulitzer), 200 numbered copies, signed by the artist. The first 100 copies contain three more poems, three more illustrations and an additional spot of a cupid.

1928 *Candide,* Jean François Marie Arouet de Voltaire, Illustrated by Rockwell Kent, Random House, New York, 1928. 4to. Bound in gold embossed maize buckram. 122 pages. 81 illustrations, as well as decorative initials, end-papers, and paragraph marks. Printed by Pynson Printers, 1470 numbered and signed copies, as well as 95 special copies (bound in decorated linen and morocco) with the illustrations colored in the studio of the artist. Reset in Garamond type for the second edition, 1929, (bound in red cloth), as well as for the special edition issued by the Literary Guild, 1929, (bound in blue cloth).

The Bookplates & Marks of Rockwell Kent, 1929 With a Preface by the Artist, Made by Pynson Printers for Random House, New York, 1929. small 8vo, Bound in blue cloth with gold stamping. 80 pages. 85 illustrations, 1250 signed and numbered copies.

Moby Dick, or The Whale, By Herman 1930 Melville, Illustrated by Rockwell Kent, Chicago, 1930. 3 volumes, 1000 sets in aluminum slipcase. 4to. Bound in black cloth stamped in silver. Printed at the Lakeside Press. 280 illustrations. Reset in smaller format for Random House trade edition, 1930. Also deluxe edition, Garden City, and Modern Library edition. There are many foreign editions of this book, including Russian.

The Canterbury Tales of Geoffrey Chaucer, 1930 Together with a Version in Modern English Verse by William Van Wyck, Illustrated by Rockwell Kent, Published in New York by Covici-Friede, 1930. Folio. 2 volumes. Bound in brown linen. 262 and 194 pages, with 24 full-page illustrations in 2 colors and 55 head and tail pieces (many repeated). 1000 signed and numbered copies, of which 75 were editions de luxe, bound in pigskin and accompanied by special portfolio of Kent plates. Trade edition by same publisher, 1934; Garden City reprint, with Modern English by J. U. Nicholson, 1934; English edition, 1934.

N by E, Rockwell Kent, New York, Random 1930 House, 1930. 4to. Bound in blue linen with silver decorative stamping. 252 pages. 108 illustrations in blue-gray ink. Printed by Pynson Printers in edition of 900 numbered and signed copies. Trade edition, reset in smaller format, 8vo, printed by The Lakeside Press, bound in gray cloth with blue stamping, and issued by Brewer and Warren. Also special edition for the Literary Guild, same year, in gray cloth with green stamping. There was also a special author's edition of 100 copies, slightly larger, and containing one extra design and a presentation poem.

A Birthday Book, By Rockwell Kent, Ran- 1931 dom House, New York, 1931. 4to. Bound in silk lithographed in blue and stamped in red. 56 pages. 20 illustrations in greenish black and white, set in frames of text and decorative designs in gray and olive green. 1850 copies numbered and signed. Printed by Pynson Printers. Some of the black-and-white illustrations first

appeared in *The Golden Chain, A Fairy Story,* which was privately printed in a limited edition of only 8 copies.

1931 *Venus and Adonis,* By William Shakespeare, Illustrated by Rockwell Kent, Rochester, The Printing House of Leo Hart, 1931. 4to. Bound in tan silk with leather back. Printed by Leo Hart and Will Ransom. 1250 numbered and signed copies. 21 illustrations in black and red. Trade edition by same publisher in reduced format, 1934. Also a pirated edition printed in Paris.

1932 *Beowulf,* New York, Random House, 1932. large 4to. Bound in rough gray linen with white decorative stamping. 156 pages. 8 original lithographs (printed by George Miller) besides numerous initial letters in blue and red. Text hand-set in American Uncial. Printed by Pynson Printers in edition of 950 copies signed with Kent's thumbprint.

1934 *Erewhon,* By Samuel Butler. Now Printed From the Revised Edition of MCMI, by the Pynson Printers of New York in MCMXXXIV for the Members of The Limited Editions Club, With a Special Introduction by Aldous Huxley and the Illustrations and a Special Design for Each Chapter Made by Rockwell Kent. 4to. 252 pages. Bound in silk lithographed in blue and gray. 10 full-page illustrations in two colors, and 29 chapter heads, title-page and colophon designs printed in light brown ink. 1500 numbered and signed copies.

1935 *Salamina,* By Rockwell Kent, Illustrated by the Author, Harcourt, Brace & Company, New York, 1935. 8vo. Bound in natural linen stamped in blue. 370 pages, plus 20 tipped-in sheets. 92 illustrations. This book is a bibliographer's nightmare because of over 30 years of various editions, which include an author's edition of 100 copies, variants of trade editions with different bindings, and foreign translations.

1936 *The Complete Works of William Shakespeare,* Doubleday, Doran & Co., Garden City, N.Y., 1936. 4to. Two volumes, bound in blue buckram with parchment label printed in gold in a boxed edition of 750 copies signed by Kent. 40 full-page illustrations, including frontispieces, printed in 2 colors. Trade edition bound in green buckram stamped in gold. Also one-volume edition, Garden City Publishing Co., 1948. Doubleday, Doran also issued a limited edition of the illustrations alone, matted and boxed, with one reproduction signed.

1936 *The Saga of Gisli, Son of Sour,* Translated from the Old Icelandic by Ralph B. Allen, Illustrated by Rockwell Kent, Harcourt, Brace & Co., New York, 1936. 8vo. Bound in natural buckram stamped in black. 160 pages. 14 illustrations, including two double-page spreads.

1937 *Leaves of Grass,* By Walt Whitman, Illustrated by Rockwell Kent, The Heritage Press, New York, 1936. 4to. Bound in green morocco stamped in gold. 570 pages. 1000 copies signed by Kent, with 126 illustrations, with frontispiece in 2 colors. Trade edition the same but bound in green cloth and dated 1937.

1939 *Later Bookplates & Marks of Rockwell Kent,* With a Preface by the Artist. Made and Published by Pynson Printers, New York, 1937. Small 8vo. 84 pages, 96 illustrations. Bound in rust brown cloth with gold stamping in edition of 1250 numbered and signed copies.

1940 *This is My Own,* By Rockwell Kent, With Drawings by the Author, Duell, Sloan and Pearce, New York, 1940. 8vo. Bound in natural finish buckram with dark blue stamping. 410 pages. 101 illustrations. Second impression, 1941, with corrections and minor changes. There was also a slightly different special edition for the newspaper, *Friday.*

1941 *Paul Bunyan,* by Esther Shephard, Illustrated by Rockwell Kent, Harcourt, Brace & Co., N.Y., 1941. 8vo. Bound in tan cloth with blue stamping. 22 full-page illustrations, plus title-page drawing and 38 illustrated initials and other smaller illustrations. Reprints by same publisher.

1941 *Goethe's Faust,* A New American Translation by Carlyle F. MacIntyre, With Illustrations by Rockwell Kent, Together with German Text, New Directions, Norfolk, Connecticut, 1941. Bound in natural buckram stamped in red and gold. Contains 9 double-page drawings by Kent. Designed by Ward Ritchie and printed at the Stratford Press in an edition of 100 numbered and signed copies. Trade edition by same publisher issued simultaneously; also reprint in small format, 1950.

1946 *To Thee, America!* A Toast in Celebration of a Century of Opportunity and Accomplishment in America 1847–1947, Written and Illustrated by Rockwell Kent for Rahr Malting Co., Manitowoc, Wisconsin. Privately printed [by A. Colish, New York] 1946. 4to. Bound in coral pink laid paper over boards with blue cloth spine, gold stamped decorations. 60 pages. 48 illustrations and decorations by Kent.

1948 *A Treasury of Sea Stories,* Compiled by Gordon C. Aymar, Illustrated by Rockwell Kent, A. C. Barnes & Company, New York, 1948. 8vo. Bound in sea-green buckram stamped in white. 480 pages. 10 illustrations.

1949 *The Decameron of Giovanni Boccaccio,* Translated by Richard Aldington, Illustrated by Rockwell Kent, Garden City Publishing Company, Inc., Garden City, New York, MDCCCCXLIX. large 8vo. Bound in maroon buckram with gold stamping, 2 volumes, boxed. Total of 596 pages, with 32 full-page illustrations in black with washes of two colors, plus title-page drawing and section heads. Limited edition of 1500 numbered and signed copies. Trade edition in maroon and tan cloth. Later editions in green cloth and tan backstrip.

1963 *Rockwell Kent's Greenland Journal,* Ivan Obolensky, Inc., New York, 1962. 8vo. 320 pages. Bound in blue-green cloth stamped in silver. 79 illustrations, including map end-papers. The limited edition of 1000 numbered copies was printed simultaneously. These are bound in natural finish white cloth stamped in gold, in a two-compartment slip-case also containing a folder with six original lithographs by Kent, one hand-signed by the artist. Both editions were actually published in February, 1963.